D1276123

HILARY WESTON
WT
W
WRITERS TRUST PRIZE FOR NONFICTION

FINALIST

BEST
BOOK

"[*Birds Art Life* is] like a tidy cupboard brimming with beautiful objects—each one taken from a shelf, examined for a short time and returned, to allow another to reveal its wisdom."
—*The Globe and Mail*

"Maclear offers a lyrical ode to the beauty of smallness, of quiet, of seeing the unique in the ordinary."
—*Maclean's*

"*Birds Art Life* is a charming book, as delicate as a warbler's plumage."
—*Winnipeg Free Press*

"[Kyo Maclear's] writing is marvelously pure and honest and light." —Barbara Gowdy, author of *The White Bone* and *We So Seldom Look on Love*

"A beautifully crafted memoir that elevates the ordinary with intelligence and humility."
—Leslie Feist, musician

KYO MACLEAR

BIRDS ART LIFE

Anchor Canada

LIBRARY AND ARCHIVES CANADA CATALOGUING IN PUBLICATION

Maclear, Kyo, 1970-, author
Birds art life / Kyo Maclear.

ISBN 978-0-385-68753-9
eBook ISBN 978-0-385-68752-2

1. Maclear, Kyo, 1970-. 2. Bird watching—Ontario—Toronto.
3. Birds—Ontario—Toronto. 4. Nature—Psychological aspects. I. Title.

QL685.5.O5M176 2018 598.072'34713541 C2016-903007-5

Illustrations (interior and cover): Kyo Maclear
Photography (interior): Jack Breakfast (www.smallbirdsongs.com),
unless otherwise indicated
Cover design: based on a design by Lauren Peters-Collaer
Book design: CS Richardson

Printed and bound in the USA

Published in Canada by Anchor Canada,
a division of Penguin Random House Canada Limited
A Penguin Random House Company

www.penguinrandomhouse.ca

10 9 8 7 6 5 4 3 2 1

Penguin
Random House
ANCHOR CANADA

For David

Someone has put cries of birds
on the air like jewels.

ANNE CARSON

Contents

WINTER

PROLOGUE

On facing a father's illness
and finding that grief takes strange forms,
including wanderlust.

One winter, not so long

ago, I met a musician who loved birds. This musician, who was then in his mid-thirties, had found he could not always cope with the pressures and disappointments of being an artist in a big city. He liked banging away on his piano like Fats Waller but performing and promoting himself made him feel anxious and depressed. Very occasionally his depression served him well and allowed him to write lonesome songs of love but most of the time it just ate at him. When he fell in love with birds and began to photograph them, his anxieties dissipated. The sound of birdsong reminded him to look outwards at the world.

That was the winter that started early. It snowed endlessly. I remember a radio host saying: "Global warming? Ha!" It was also the winter I found myself with a broken part. I didn't know what it was that was broken, only that whatever widget had previously kept me on plan, running fluidly along, no longer worked as it should. I watched those around me who were still successfully carrying on, organizing meals and careers and children. I wanted to be reminded. I had lost the beat.

My father had recently suffered two strokes. Twice— when the leaves were still on the trees—he had fallen and been unable to get up. The second fall had been particularly frightening, accompanied by a dangerously high fever brought on by sepsis, and I wasn't sure he would live. The MRI showed microbleeds, stemming from tiny ruptured blood vessels in my father's brain.

The same MRI revealed an unruptured cerebral aneurysm. An "incidental finding," according to the neurologist, who explained, to our concerned faces, his decision to withhold surgery because of my father's age.

During those autumn months, when my father's situation was most uncertain, I felt at a loss for words. I did not speak about the beeping of monitors in generic hospital rooms and the rhythmic rattle of orderlies pushing soiled linen basins through the corridors. I did not deliver my thoughts on the cruelty of bed shortages (two days on a gurney in a corridor, a thin blanket to cover his hairless calves and pale feet), the smell of hospital food courts, and the strange appeal of waiting room couches—slick vinyl, celery green, and deceptively soft. I did not speak of the relief of coming home late at night to a silent house and filling a tub with water, slipping under the bubbles and closing my eyes, the quiet soapy comfort of being cleaned instead of cleaning, of being a woman conditioned to soothe others, now soothed. I did not speak about the sense of incipient loss. I did not know how to think about illness that moved slowly and erratically but that could fell a person in an instant.

I experienced this wordlessness in my life but also on the page. In the moments I found to write, I often fell asleep. The act of wrangling words into sentences into paragraphs into stories made me weary. It seemed an overly complicated, dubious effort. My work now

came with a recognition that my father, the person who had instilled in me a love of language, who had led me to the writing life, was losing words rapidly.

Even though the worst of the crisis passed quickly, I was afraid to go off duty. I feared that if I looked away, I would not be prepared for the loss to come and it would flatten me. I had inherited from my father (a former war reporter/professional pessimist) the belief that an expectancy of the worst could provide in its own way a ring of protection. We followed the creed of preventive anxiety.

It is possible too that I was experiencing something known as anticipatory grief, the mourning that occurs before a certain loss. Anticipatory. Expectatory. Trepidatory. This grief had a dampness. It did not drench or drown me but it hung in the air like a pallid cloud, thinning but never entirely vanishing. It followed me wherever I went and gradually I grew used to looking at the world through it.

I had always assumed grief was experienced purely as a sadness. My received images of grief came from art school and included portraits of keening women, mourners with heads bowed, hands to faces, weeping by candlelight. But anticipatory grief, I was surprised to learn, demanded a different image, a more alert posture. My job was to remain standing or sitting, monitoring all directions continually. Like the women

who, according to legend, once paced the railed rooftop platforms of nineteenth-century North American coastal houses, watching the sea for incoming ships, hence earning those lookouts the name widow's walk. I was on the lookout, scouring the horizon from every angle, for doom.

It was only later, when I read C. S. Lewis's *A Grief Observed*, that I understood grief's many guises and iterations. "No one ever told me that grief felt so like fear. . . . Perhaps, more strictly, like suspense," Lewis wrote. "Or like waiting; just hanging about waiting for something to happen. It gives life a permanently provisional feeling. It doesn't seem worth starting anything. I can't settle down."

The grief I felt was not upending my life. It did not, for instance, prevent me from socializing and exercising and tracking down orange blossom water for a new cake recipe. It did not prevent me from lying in corpse pose in a crowded yoga studio, simulating my own proximity to the void. But it unmoored me and remained the subtext of my days.

One night I looked in the mirror and noticed my eyebrows were aloft. I tried to relax my face, make my brows those of a different, more carefree person. The next day, while sitting on the streetcar, I watched a woman whose eyebrows had been carefully pencilled in and thought how cartoonishly worried she looked

with those skinny, fretful arcs. Like me, I thought, like everyone.

The worry was heavy and I tried to put it down. I tried to read my way out of it. I tried to distract myself from it. I tried to write my way through it. Ordinarily my art could withstand the pressures of life, the demands of young children and aging parents. But that year when the snow came early I discovered I had a wan and flimsy art, one that could be smacked down like a cheap sidewalk sign with the slightest emotional gust.

Or maybe I discovered something more fundamental: worry is a constriction. A mind narrows when it has too much to bear. Art is not born of unwanted constriction. Art wants formless and spacious quiet, anti-social daydreaming, time away from the consumptive volume of everyday life.

My relationship to time, my attitude towards it, grew fickle. I wanted an expanse of it. I wanted just a little. It moved too quickly. It crept too slowly. It was overly determined by forces outside myself. It overwhelmed me if I was left to define its shape. It was best late at night after my village slept. It was only good in the very early morning before the village awoke and the hours and minutes were set.

I had grown so accustomed to being interrupted by emergency calls and hospital news, I began interrupting

myself whenever I sat down to work. I leapt up from my seat every half-hour as though an alarm had sounded. Time used to be deeper than this, I thought.

I studied the eyebrows of writers and artists I respected. I researched famous eyebrows. Frida. Audrey. Greta. Groucho. "Brows may be a map of the psyche," reported one fashion magazine. I looked for the secret recipe (impeccable elegance, theatrical boldness, unkempt creativity, flirty merriment) that fed people and made them flourish. I wanted a road map back to my art and equanimity.

One morning while standing at a café counter staring at the magnificently thick brows of the man making my coffee, I discovered one should not gaze too long at faces unless one is prepared to fall in love again. As I watched the warm air of the coffee machine steam his eyeglasses, as I noticed him squint behind the fog, as he made a flower pattern in the foam of my coffee, I felt overcome with love. Faces have a near-unwatchable intimacy, particularly in a world in which everything perishes in the end. It is difficult to look as we choose, without emotional consequence.

Like me, the man looked very tired. What had he lost? What was he about to lose? Was he trying to get his grieving done ahead of schedule?

A few days later, I was charmed by a man at the gym and the thoughtful way he wiped down the treadmill

"The original queen of bold brows"
(Audrey Hepburn)

"Eybrows perpetually slightly raised"
(Anne Carson)

Arching "his eyebrows about ten degrees"
(Buster Keaton)

"Thick, black, expressive eyebrows"
(Hayao Miyazaki)

for me. I was charmed by a chiropractor and the way my body flooded with endorphins when he leaned into his adjustment. I was charmed by the kindness of a stranger who let me slip in front of her at the grocery checkout. The professor, the café manager, the dog walker—I ran away with each of them in my mind, and this scared me because I come from a long line of philanderers. "Be careful," whispered the guardian angel on my shoulder. "Remember how much you love your husband."

I knew in my heart that I didn't want to fall in love with another person. I wanted to fall in love with something bigger. Something that would hold me and my wandering mind. Something, like a love affair, that would allow me to say: I am here, I am alive. I am doing more than calmly bracing myself.

It was not enough to be a vigil flame, contained and burning around the clock.

As my days became increasingly plotted, I developed a bad case of wanderlust (Ger. *wandern*, to hike, and *lust*, desire).

I began to envy the literal wanderers, the ones out in the dark seas, or breaking away to hike up mountains and along the Pacific Crest trail. I dreamt of following footprints on a path, of going where the wild things are. But I had never been a Great Outdoors traveller. I was an urban person, a city-identified post-colonialist.

The thought of pointing and gasping at something spectacularly beautiful on a warming planet felt dismal. Such was my state of mind. The feeling of pre-grief had made a home in my body. The shadow of an ending in my own family had made me alert to other endings.

Death is the definition of finitude. My wanderlust, I began to feel, was about finding my way back to infinity, back to the woods of a creative and contemplative mind.

I dreamt again of footprints on a path and realized when I awoke that it was not escape that I craved but guidance. For weeks, I sought instruction wherever I went. Please, YMCA lifeguard, will you coach me on my freestyle? Please, elaborately coiffed greengrocer, can you tell me how to cook these bitter greens? I wanted gifts of knowledge. I wanted company.

I wanted someone to lead the way forward and keep me going. Not a saviour but a guiding force. I was ready to imprint myself like a duckling.

I contacted a well-known artist to discuss the possibility of drawing lessons. As a child, I used to draw all the time. It absorbed me completely. At some point, writing replaced drawing and what had once been second nature (drawing) became foreign. But the urge to draw had remained. I missed its simple and primordial pleasures.

The artist met me at a café wearing a black parka and a delicate grey-blue scarf and appeared doubtful that she was in the right place, even after I introduced myself. When she ordered a small chai, I ordered the same, companionably affirming her choice. When she straightened her spine, I instinctively did the same. When she asked me why I wanted her to teach me drawing, I replied, "Sometimes you just want to sit back and be led." Realizing this sounded strangely passive and messianic, I added, "Through drawing prompts." I didn't want her to think I was looking for a guru or that I was the kind of person who would just hand myself over to someone else. I also did not want her to hear my hunger, because to hunger as much as I did at that moment felt lascivious.

The artist peered at me thoughtfully. Her blue eyes were clear and perfectly lined with kohl. Finally she spoke, with a hint of bemusement. She said the students who came to her were always full of hunger. They were seventeen-year-old aspiring artists and eighty-five-year-old retired businessmen. People of mourned, mislaid, or unmined creativity. Their yearning was like the white puff of a dandelion. All she had to do was blow gently and watch their creative spores lift, scatter, and take seed.

We sat by the window and watched the clods of fresh snow thrown up by the feet of passersby, the uprush of wings when a flock of pigeons startled into the now

white winter sky. Angles of light, intensities of shadow, the way the sky clouded and cleared and the streetcars gorged and disgorged passengers. I felt the artist's full-body noticing and the passing time.

I looked across the street at the signs hanging on the discount store.

DON'T JUST STAND THERE, BUY SOMETHING!

THERE'S NO BUSINESS LIKE SHOE BUSINESS!

FREE 12-PACK OF RACCOONS
FOR EVERY VISITOR!

I knew at that moment I would not pursue private art lessons with this woman who, to be truthful, unnerved me with her quiet concentration and pin-straight posture.

I went home and pulled out my ancient brushes and pen nibs and old bottles of ink. I spent a little time sharpening my drawing pencils and cleaning my stubby grey erasers. I found a block of drawing paper. I looked at the sharpened pencils and for a moment they were arrows. They were arrows pointing to all the things that could not be captured with words, arrows pointing to other possible lives, potentialities, directions, even backtracks. I was waiting to be led by a line, in this case a pencil line.

In that moment of stillness, I realized I might also have been grieving the longer spans of time that allowed me to get a lift out of daily life.

As I sat with those arrows, as illness and caregiving further compressed my days into tiny snippets of moments, I had a growing feeling that my life, with its new shape and needs, required a different, less militant arrangement of time. What if I stopped fighting for the trance of long-form days, where I would be uninterrupted and ambitiously absorbed in a big project? What if I gave myself over to time's dispersion? Could I value the fractured moments as something more than "sub-time" or lost time or broken time? Could I find a graceful way to work and be in the world that might still pull me up and forward?

I wish I could say that in the weeks and months to come I no longer felt at war with the world, but that was not the case. I am a self-employed writer. It is not easy to stop being unstoppable. (Just ask the pronghorn who continues to outrun the ghost of predators past.) I still tried to protect and fortify myself against invasion from time-looting bandits, still moved through the world as if I were perpetually on-task, trying to focus on nothing but what was in my own head and what I might make.

But I did begin to make peace with my fragments.

December

LOVE

{

GEESE, SWANS, DUCKS
A HAWK, *and* A PIGEON

}

On falling in love with birds
and discovering other lessons
in insignificance.

Then there were the

birds, which were suddenly everywhere. I could hear them in the trees and tucked in the eaves of our house: idle choirs chattering and trilling—pretty songs and ugly songs, songs to pass the time. A hawk perched high above the ice rink while I was skating with my sons one afternoon. I spied a flock of migrating geese through a skylight while I did the backstroke in a YMCA pool. It moved like a giant cursor across the white flatness of the sky.

One evening I returned from visiting my father at the hospital and curled up on the couch in my composer-husband's studio. I reeked of Purell hand sanitizer and the sweat that comes from acting chipper. The studio was the most soothing place I knew. The walls were covered in blue fabric and hanging baffles. These baffles, made of wavy grey foam, were designed to eliminate echo and absorb sound. A floating floor further reduced impact noise. I melted into its womb-like comfort.

My husband played a track he had made for a movie, ghostly and piano-driven. I wore his hat, which I had pulled from his coat tree. I wrapped myself in a wool cardigan handed down from his grandfather and rested my feet on his thrift-store coffee table. He turned on the Swan Silvertones and filled my heart up with gospel handclaps and perfect harmonies.

Together we watched a rough cut of the film he was scoring. It was a documentary titled *15 Reasons to Live* based on a book by a Canadian writer. The film was divided into fifteen stories, loosely representing the chapters in the book, and tackling the question of what makes life worth living.

For example, a chapter called "Love" followed a Quebecois man who found solace in walking around the world as he recovered from a mental breakdown. "Body" told the story of a man whose debilitating anger had led him to pursue the art of rock balancing. Halfway through, a thirty-something musician appeared in the segment titled "Meaning." After years of wallowing in creative depression, he had quit drinking and found peace by birding in the city. "I didn't even have to think about it. I just felt easier. I felt easy-hearted," he said.

He had discovered his joy was bird-shaped.

The musician was funny and had a smile that was very quiet. He came across as fervent about birds without being reverential.

Later that evening I looked at the musician's bird photographs on his website. It was an extensive and odd collection. They were not the sorts of pictures you would see on a greeting card or in a glossy bird calendar.

These birds lived in gardens of steel, glass, concrete, and electricity.

There was a bird with a plastic FROZEN MANGO bag on its face and another bird nested in a shattered light fixture. There were birds on tacky stucco walls, rebar bundles, giant forged nails, and wire fences. The birds were doing ordinary bird things—perching, flying, preening, hunting, nest-building—but there was no doubt that they were of rather than above the mess and grit and trash of the world.

The message in the photos wasn't the usual one about environmental sins or planetary end times. The message, if it could be called that, was about love. It wasn't love for a pretty girl or a love that placed the beloved on a plinth or in a vitrine. It was not the kind of love that knocked you over, left you in a state of craven hunger, and gave you jittery bouts of insomnia. It neither idealized nor sought to possess. The love I felt in the photos was a love for the imperfect and struggling. It was a love for the dirty, plain, beautiful, funny places many of us call home.

My heart beat a little faster looking at them, at the birds and the space around them.

I had grown solitary while waiting for the world to quieten around a story. I had grown solitary as an only child of two aging immigrants who had fled their respective homelands for a continent devoid of family, who had drawn a strike-line through their histories, who sat on the land like two potted plants rather than trees in soil. I had grown solitary as a writer whose craft demanded my separation from others. Is that what I saw in the space around the birds? My own solitude?

I made contact with the musician and arranged to meet him for a bird walk. I wanted to be enraptured and feel I was still inspirable. I did not see nature as my own personal Lourdes or healing wilderness.

Or maybe I did.

"Hello?" the musician said, loping towards me with his heavy camera, a stout figure in layers of woolly brown. "Hello?" I replied. I was standing by a large duck pond on a cold but sunny December morning, exhaling cloudlets of breath. People walked by on the path with their dogs. Ducks waded past us on the water.

I had sudden misgivings. I felt shy. What had I been thinking?

The musician was a serious birder. I belonged to the vast numbers, satirized by *Portlandia*, who knew nothing about birds and thought mostly of them as a decorative motif. My house was a frivolous bazaar of nature-themed trinkets, from the prettiest handcrafted duck lamp to the usual menagerie of stuffed toys to our Anthropologie owl mugs. I lived in a state of unforgivable anthropomorphism. Anthropoapologetic. That's what I was feeling.

What did I know of live birds? What did I know of the wild world, and what did it know of me?

I did not grow up picking berries by a river valley or clambering through dark, dewy forests or observing tide pools. I had many adventures as a child, but they did not involve the wilds of Canada. They involved casinos, international airports, and mammoth department stores.

My parents were devoutly metropolitan. My father was a London-born foreign correspondent, stationed in Tokyo when he met my Japanese mother, a demure, long-haired sumi-e artist who initially balked at my father's immense height and skeletal bearing. Their courtship began at a Canadian Embassy party in a thick fug of cigarette smoke. He fell in love with her charm and prettiness. She fell in love with his worldli-ness and the promise of escape.

They married, and a couple of years later, work

drew my parents to London, where I was born. And then another job drew them to Canada. An exotic cosmopolitan couple had suddenly landed in a quiet North Toronto neighbourhood. No Kensington High Street, no Shinjuku, just a thick blanket of snow. Just unidentified scampering animals and unfamiliar winged creatures. My father dashed off somewhere for work and my mother was left alone in a cold house. Quiet quiet, no noise except the birds outside, a choir on their way from or to elsewhere, birds thriving in their new territory. All those notes held in the cold air, the migrant songs, were not a comfort to my mother. Having lived through hardscrabble war years in the Japanese countryside, she had no fondness for nature. She liked busy downtowns, a thick cladding of civilization. She liked sashaying down the street in a miniskirt and heels, Rothmans cigarette in hand, and causing an uproar. My mother was beautiful and boasted she had, on various occasions, turned the heads of such men as Mick Jagger, John Lennon, and King Hussein. Toronto did not impress her. Instead of appreciation, my mother looked out her icy Canadian window and saw problems. What to do with all the fucking snow? What to do with the fucking gazebo?

Here's what she did. When spring came she dug up the entire backyard and installed a traditional Japanese rock garden, a carefully ordered and manicured land-scape, which she raked with monkish regularity, clearing away Frisbees, badminton birdies, and baseballs

24

that sailed over the fence from the park behind our house. If she had to have nature, she would have it her way: soft sprinkler-grown moss and carefully pruned Japanese trees. She did this every time we moved, creating four new rock gardens in seven years. Raking and raking her way to happiness.

My mother became an art collector and gallerist. (Her own ink paintings, dating back to her pre-married life, had been left behind in Japan, so acquiring the lustre of legend.) I grew up in a house cluttered with precious items and bizarre junk, newly acquired antique furniture, mementoes of strangers. Our tiny nuclear family became a country all its own with its own unique and insular customs.

The musician eased my shyness by talking me through the ducks on the pond. *There*, he said, see those ducks landing on the water, the ones that look like clumsy seaplanes, those are mallards. *And over there*, that funny cluster swimming in a tight circle in the middle of the pond—see? Eight, nine, ten, eleven of them churning food to the surface—those are northern shovellers. He pointed to a solitary duck that resembled a large turkey bobbing on the water, a cross between a farm duck and a mallard. Apparently his mate had died recently. She disappeared one day and there were rumours of a carcass sighting.

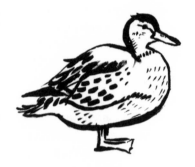

Mallard (female)

Can a duck feel lonely? I wondered but I did not know.
I didn't know anything about ducks. I didn't even know
about the oil that coated their feathers, which was
strange because I had probably heard the expression
"like water off a duck's back" a thousand times.

The farm duck–mallard seemed to be enjoying him-
self. He was cruising around the various duck cliques,
chatting up the ladies. He was a duck with charisma.

Did the musician have charisma?
 A little.
 Did the musician grow up feeling close to nature?
 No.

The musician told me he grew up in a city-bound family. He had only one boyhood memory of nature—which involved catching a caterpillar when he was six. He placed the caterpillar in an empty margarine container, laid down some grass for food, and closed the lid. No one had taught him that he needed to create air holes. So he sat, watching and waiting for his future butterfly.

He told me: *I started going on bird walks to get out of my studio and out of my head. I used to worry about being loved as an artist. I wanted to be understood. I wanted to be admired. I wanted to be significant! I wallowed in a shitty state of insecurity most of the time. Now I spend hours trying to spot tiny distant creatures that don't give a shit if I see them or not. I spend most of my time loving something that won't ever love me back. Talk about a lesson in insignificance.*

The moment of us not knowing each other quickly receded. I was used to being around people who were somewhat hobbled by their artistic temperaments. What differentiated the musician was that he had made an unusual change in his life, separating himself from the competitive world and from the imperative to feel tragic about things, but otherwise he was still a familiar duck.

"Let's walk," he said.

I followed him on the path.

As we walked, I was thinking about something I had just read in a book by Amy Fusselman: "You would be surprised at how hard it is to be open to new and different good things. Being open to new things that are bad—disasters, say—is pretty easy. . . . But new, good things are a challenge."

Part of being open, I decided, meant cultivating a better kind of attention. I wanted to achieve the benevolent and capacious attention that the be-scarfed artist and the bird-loving musician showed the world.

My usual (non-maternal) attention had three strains. There was the dogged attention I gave my art, the boxed-in attention I gave to my devices and screens, and the durational attention I (sometimes) gave to challenging books/art/films. All these seemingly dissimilar forms of attention had something in common: they were on their way someplace. They sought a reward, a product purchase, a narrative connection.

Was it possible that my focus on making art, on creating tellable stories, was intercepting my ability to see broadly and tenderly and without gain? What would it be like to give my expansive attention to the world, to the present moment, without expectations or promise of an obvious payoff? Was I capable of practising a "God's love" kind of attention? An adoring and democratic awe? Could I be more papal?

The musician was oblivious to the questions moving through my head, questions that had developed a weird ecclesiastical cast, as we walked. He was too busy peering into shrubs, grandly and generously giving his attention to the birds—leaning to hear, bending to see, falling silent when he heard a melody, looking for the singer.

My sons were whistling when I returned home. My elder son had taught my younger son how to carry a tune, and I listened to them in their bunk beds whistling into the night.

On the street a few days later I spied a young man moving strangely on the sidewalk. He was stepping forward, then stepping back. He was leaning to the side, then stepping forward, then stepping back. Sometimes my husband and I do a pretend modern dance, and this reminded me of that. I crossed the street to see why the man was dancing on the sidewalk.

Lying there, broken and flightless, was a pigeon with a bloody severed tail. I unearthed a gym towel from my bag, and we encircled the bird and carried it gently to a sheltered doorway. Then we crouched down and tried to make eye contact. I don't know if the bird took us in with its glazed eyes or if it felt absolute indifference, but we took the bird in as it grew increasingly still.

I had seen dead birds before but I had never seen a bird die. Rationally speaking, I knew the pigeon wasn't a message. I am not a sign-seeker who scours the skies for mystical portents, yet over the years I have developed a certain faith in chance and serendipity. I would not be here but for the accident of two ill-suited people meeting under unexpected circumstances. I would not have met my husband had I not walked through an unlikely door on an improbable evening. So after the pigeon, after a few more days of unusual and banal bird encounters, I began to feel that I was being told what to do next. I would learn about birds. I sent the musician a note and asked if I could follow him for a year.

The musician said yes.

Husband: *What are you writing about?*
 Me: *Well* . . .

My husband is far too loyal and drowsy to doubt me. If I embark on a fantastically ill-conceived journey I know he will be the guy throwing paper streamers in the air and hooting Farewell! Farewell!

This is what we do. We cheer each other on in our misadventures.

We did this for my father when he escaped from his hospital bed later that winter. He called us from a taxi, recounting his jailbreak as if he had just dug a tunnel to freedom using a spoon, when really he had rolled his walker to the elevator, travelled a few flights to the concourse, and flagged a cab right outside the hospital doors. Breathless with excitement and emphysema, my father jokingly imagined an epic—maybe a nation-wide—manhunt. For a moment he was a fugitive, not a patient.

When we cheered my father on and celebrated his getaway, it was not because we were diminishing the medical ramifications of his escape (the doctor would call to reproach us soon) but because we knew that there was something bigger at stake.

There are moments when what we need, what will benefit us most, is the power to style our own stories.

That's what we were celebrating when we sat in my father's small kitchen, eating the homecoming lunch my husband and I had brought. We were in a moment of repose. There was nothing to be done or to be put in place. My father felt more alive and durable than he had felt in a long time.

So when my father asked what I was working on, I told him.

"I am thinking of writing a book about birds and art," I said (though I hadn't started; the words and will still slowly forming).

I put on an open and trusting face, which was an effort because my father who had been slightly forward-leaning through lunch was now leaning back and looking at me blankly as if I had just described plans to write a book on farming with wooden implements.

We sat there having a silent conversation.

Why?

Why not?

Couldn't you write something a little more useful? A bigger book?

My father, who likes things distant and serious, thinks I write too close and peculiar. He is drawn to the largeness of things, to epic battles and big History, the clash of civilizations. Birds are too compact and ordinary for him.

It is possible we are destined to be like the father and daughter in Grace Paley's "A Conversation with My Father," who misunderstand each other "on purpose." For example, as we sat in his kitchen that day, I knew my father believed I had chosen birds to deliberately antagonize him, just as I believed his dismissal of nature and art was a dismissal of me. Neither of us was entirely to blame for this dynamic. When I became a writer, I entered the family business and he assumed the mantle of mentor.

A few "useful" books written by my British kin: *The Hour of Sorrow, or the Office for the Burial of the Dead: With Prayers and Hymns* by George Maclear, *Sailing Directions for Bering Sea and Alaska, Including the North-East Coast of Siberia* by John Fiot Lee Pearse Maclear, *Catalogue of 4,810 Stars for the Epoch 1850* by Thomas Maclear, *The Ten Thousand Day War: Vietnam 1945–1975* by Michael Maclear.

My husband, who had been staring at the ceiling while my father and I had our first silent conversation, registering his desire to escape, glanced over at us as we softened into our second one.

 Pain?
 Yes.
 Where?
 Here. Here. Here.

My father's face was now ashen. I nodded at my husband: Time to leave. My father needed to rest. While he struggled to stand, I had a moment of clarity: I had just told my father, a man who did not have time to waste, that I was writing a book on something obscure and indefinable. Could I not, for his sake, choose a less artisanal subject?

I wasn't too concerned. At a certain stage, these matters within families don't get worked out, they just get half-heartedly poked at or ignored. I knew my father would choose to forget what I had said and ask me again a few days later: "So what are you working on?" And if the answer still did not satisfy, he would ask again and again and again.

I, in turn, would make things up in response, not because I am an admirable daughter but because I do not want anyone deciding for me what is big and what is little. I do not want fashion or fathers to decide.

Because it's never that simple. I can pretend not to care and still be wishing for his interest, his engagement, his assent.

What is worth singing about? What if the song is too small? Books will tell you that birds sing for a number of reasons—to call to each other, to warn of predators, to navigate, to attract mates. But I wasn't so much interested in what the books believed. I wanted to know what the musician believed. "Why do birds sing?" So at the end of our first bird walk together, I asked. I wanted him to say they sing because they have to, because they must, because it is part of their very essence, an irrepressible need.

"I don't want to get all whimsical," he said. "Anthropomorphism is a dangerous habit and a hard one to break."

I hesitated, acknowledging to myself that it was possible and likely my habits of anthropomorphism were unbreakable. "I promise I won't tell anyone."

Slowly the musician nodded. Finally, he said,

"Ok. It's *possible* that birds may sing just for the joy of it."

I don't know why his response made me so happy but it did.

January

CAGES

{
AUSTRALIAN FINCHES
and CAGE BIRDS
}

On standing in a cage with captive birds
and thinking about the daily effort
to be free.

Love can be so glaring and

fierce, so full of paranoiac energy, it will obliterate you. The pressure of being an only child, single and inescapably needed, the focal point of too much parental attention, made me want to bolt. As a child, I wished for the decoy of a sibling and the buttressing support of a large extended family. As a teenager, I longed to run away, uncage myself.

In the summer of the year I turned sixteen, I jumped out of my bedroom window and ran across rooftops with my friend. A neighbour, believing there were robbers overhead, called the police but we kept running, sliding down a tree, clambering over fences while a siren wailed up the street. My friend (reader of Kerouac and Colette) kept running, her hair streaming through the night. I, on the other hand, lasted only an hour before heading home. I was worried about my

indoor cat, about whether I had left the balcony door open. The feeling of ranging off without thought for my family did not sit well with me. It produced guilt and panic.

That was the day I discovered a truth about my temperament and circumstance. My freedom and creative work needed something to radiate against, some pressure to resist, some limit to be overreached.

From that point on, the question was not "How can I flee this situation and get someplace better?" but rather "What can I do with what I have here?" I stopped dreaming of what a person could do with limitless freedom, resources, and time and became more interested in what a person could do with relative scarcity, in what abundance could be generated with modest resources, in what a mind could create in cramped quarters.

And so, less Honoré de Balzac, Rainer Maria Rilke, Philip Roth. And more Charlotte Brontë, Franz Kafka, Tillie Olsen.

When I met the musician this question of how a person introduces space and distances within the tight confines of a life took on firmer meaning and sharper focus. That he had found spaciousness in our crowded city seemed miraculous. That he was willing to lead me through a year of bird-finding filled me with gratitude. He made a difficult moment seem more habitable.

I was eager to begin. But the weather did not co-oper-
ate. We had a bird trip in mind but it was too windy.
Too cold. Too rainy. So when the musician invited me to
visit his father's aviary of finches instead, I happily went.

The musician's father, also a "birdman," built his aviary
back in 1998. With a little ingenuity and some wood
and wire he transformed a one-bedroom apartment in
a building he owned into a place where his Australian
finches could fly freely.

The musician goes to the aviary three times a week to
clean and to feed the birds. He has been doing this
since 2009, when his father asked him to cover for him
after he suffered a bad fall.

The musician became a bird lover at the aviary. He tells
a story of holding a dying finch one day and feeling
overwhelmed by its tiny heartbeat. He had never
studied a bird so closely before, never observed its deli-
cate and immaculate plumage, and the experience
altered him. He bought a camera and a lens and
learned how to use them by photographing the
finches. One compulsion led to another, and by 2011 he
had moved beyond the aviary and was spending as
much time in the field as possible, creating an ornitho-
logical map of Toronto, studying the behaviour and
habits of local birds in all seasons.

So I knew the aviary was important. What I didn't
realize was that his experience with free birds had

made him a queasy aviarist. He had grown disillu-
sioned with specialty, fetish birds. He disliked the pet
trade, which was driving some birds to extinction by
reducing wild populations that were already in decline
because of deforestation. What started off as a tempo-
rary favour to his father had turned into a burden. But
he wanted to be a good son, took this to be an invio-
lable responsibility, and this I understood.

When I ran away as a teenager I was running from
ideas about my character and my future and purpose
in life. I was running away from a story about dutiful
daughters. I returned because I didn't know where I
would go or who I would be without these ideas.

"Please don't be alarmed, I am wearing a sweater-vest,"
the musician said as he led me into the building. I
climbed the creaky narrow staircase behind him. The
sweater-vest was part of an ensemble including a wool
cap and plaid scarf that made the musician look like a
man with Prohibition-era crime ties.

The apartment added to the impression of shady
business. It was cold and spartan. There was a fridge
and a long table and stacks of cardboard boxes but not
much else. Where the bedroom might have been was
an aviary about ten by twenty-five feet. We dropped
our puffy coats on the table and the musician gave me
a pair of blue nitrile gloves and led me inside.

The contrast between the cold, derelict room and the warm-blooded chaos inside the aviary was startling. It looked like someone had thrown handfuls of French bonbons into the air. Brightly plumaged birds were flying *everywhere*—back and forth and up and down. I counted twenty birds. The musician pointed out five different species of finches. There were star finches with bright red faces, diamond firetails with crimson rumps and dazzling white spots, chocolate-coloured Bengalese society finches, several gold-breasted waxbills and a female cordon bleu. Each one was a flashy, life-filled extravaganza.

I circled the room, studying the small birds and soaking up the strange squatter ambience, as the musician moved around the aviary cleaning. There was no apparent joy in it for him. The whole situation contravened the Law of Fickle Pet Ownership, according to which it was okay for kids to pawn their unwanted pets off on their parents. But not the other way around.

His father from what I could tell was a serial hobbyist, constantly gripped by new interests. He used to build shortwave radios. Then out of the blue he decided to collect tropical fish. Then one day he abandoned fish in favour of first day covers. First day covers, the musician explained, were envelopes or cards bearing newly issued stamps postmarked on the first day those stamps went on sale. Then he became obsessed with camera collecting.

Admittedly this degree of hobby switching was unusual, and perhaps (in the case of the aviary) mildly irresponsible. But I could also see his father was very caring. His one-time affection was evident: in the perches he had built; in the makeshift birdbath, which had been rigged under the dripping faucet; and, most of all, in the possibly obscene fact that an entire apartment (one that would easily rent for $1500 a month) was the dwelling place of twenty tiny birds. Grime and clots of bird poop streaked the walls and furniture. But the birds were well preened and had healthy-looking feathers. There was ample room for them to fly.

I helped the musician fill the seed bowls in the order he directed. Then, suddenly, it dawned on me I was creating havoc. My presence inside the enclosure had sent the finches into high alert. They were making fierce loops around the room, darting from one end of the cage to the other. Their tiny little wings were beating arrhythmically as they startled from perch to perch, giving me as wide a berth as possible. Wisps of fluff and feather floated in the air. The chirping I had taken for singing was a little too strident.

It was at this point I also realized the blue nitrile gloves on my hands were not for my sake but for *theirs*—to protect them from any diseases *I* might be carrying. The aviary's feeling of quarantine had confused me. In reality, I was the galumphing invader.

To see a bird moving as if it's on fire and then realize you have ignited this anxiety challenges any illusion

you may have that you are a benign and low-impact presence in the world. For me, it triggered an awareness I had never felt so acutely. It gave me a different and more accurate view of my scale and proportions. I can't say I liked it. Who wants to feel like Godzilla when in contact with other species?

But perhaps this is the way it really is. Most of the time, we don't harm birds on purpose. Some of us may kill birds with guns and oil spills but most of us kill them with our lumbering, ignorant love—invading their habitats in bouts of nature appreciation or caging them as pets to adore—or we kill them at a distance through our technologies (communication towers, wind turbines), our windows, our medium-sized carbon footprints, or by allowing our cats to roam wild and do the decimating for us. According to a study by the Smithsonian Conservation Biology Institute, domestic cats kill between 1.4 and 3.7 billion birds every year in the United States. A separate study, from the Mammal Society, a British conservation charity, estimates that the United Kingdom's cats catch up to 55 million birds a year (a tally based on the "prey items" that cats brought home; it does not factor in kills that were not "returned").

I stood for a moment and pretended I was a harmless perch. Then I asked the musician to open the aviary door so I could leave. The musician stayed inside a little longer, doing his bird chores as I waited and watched. He was not rattling the birds.

An old-fashioned but lingering perspective from *The Illustrated Book of Canaries and Cage-Birds* (1878): "The longing for something to protect and care for is one of the strongest feelings implanted within us, and one outcome of it is the desire to keep animals under our control, which in its due place is, undoubtedly, one of our healthiest instincts."

The aviary's plainness and lack of pretense had its merits. It was once common for bird-keepers to pay inconceivable sums to build lavish architectural structures for their birds—everything from miniature Georgian mansions to replicas of the Taj Mahal or the Eiffel Tower. This aviary's wood and wire structure was utilitarian and a little depressing, but at least it was honest.

The musician moved around the aviary like a housekeeping robot, repeating the same few mechanical actions he performed several times a week, always in the same sequence, out of duty to his father. I wondered if the birds had any opinions about their confinement. Did they envy the free birds outside the window? Did they ache to be released from their long incarceration? Could it even be called an incarceration

if they had been bred in captivity? Would they know what to do with their freedom? Was it possible to be cooped up and not even notice?

There are stories of animals that have been bred in captivity experiencing the terror of the open door. It might seem counterintuitive, but captive animals often have the good sense to know their chances of survival in the wild are uncertain at best. The prospect of running away or flying off is simply too painful and frightening. So they stay put in the sanctuary of the cage.

I understand. I understand getting stuck. I understand wanting to make a change while circling around the same neural cage. I understand that sometimes, when you are at a stage of life when you have given yourself over to mothering and daughtering and you get to keep very little of yourself, it can be hard to live with open doors. Yet in an effort to hoard solitude and keep people out, there is a risk that all you end up doing is fencing yourself in.

The instinct for liberty may be deeply ingrained, but we are all captive in some way to something. We may be held in place by the confinement of tradition or trapped in relationships (family, marital, professional) that grow to feel like cupboards—comfortable, well appointed, but cupboards nonetheless. Or we may be stalled by our fear of immensities and the free fall of the unknown. We may be captive when we choose financial stability over artistic freedom, when we live

our lives like agoraphobics, confusing the safety of a locked house with security. The cage of habit. The cage of ego. The cage of ambition. The cage of materialism. The line between freedom from fear and freedom from danger is not always easy to discern.

It is not easy to be an outside bird surviving by your wits in the wild.

But what happens when you pen yourself in?

A few years ago, in Tulum, Mexico, I met an older Mayan woman who told me my liver contained some trapped fury. She referred to it as my small fist, *tu puño pequeño*. She gave me a flower that represented this portion of pent-up rage and told me to release it in the ocean.

Cut to my fourth attempt to send the ceremonial flower out to sea. Foiled by the wind, which kept whipping it back in my face, I waded farther and farther out in my cotton dress, until I was chest-deep—laughing, furious—in a froth of wavelets. *Fucking go, already*, I yelled at the flower.

I think stories of stolen flight captivate us because they're relatively uncommon. A cage-breaker is a beacon. Consider the case of Phoebe Snetsinger, who spent her early adult life in suburban Missouri, cooped up in her role as a housewife and mother of four, always working too hard to please and accommodate others. She began birdwatching when her kids were

young, as a way of getting out of the house. The rhythms of an anchored life made her uneasy, so she took long walks to places where she was no longer anyone's mother, daughter, wife, sister. She kept journeying, though always returning, until she had travelled to the world's farthest jungles, mountains, and forests. The world, she discovered, lay at her feet, open and abundant.

The ceremonial flower eventually floated out to sea.

My own mother tried to escape once. In my seventh year, she drained our family bank account and packed herself, me, and my Japanese babysitter onto a Greyhound bus bound for Niagara Falls. My father was always travelling for work and she was tired of being alone. She had put up with him, his gambling and work addictions, for fifteen years. But enough. She called my father from a payphone near the Falls and told him she was leaving the marriage. My father pleaded: "Please come home." I don't know what else was said over that epic surge of water, but when she hung up the phone, a decision had been made. She asked the babysitter to take a single photo of us standing by the Falls and then we boarded the bus back to Toronto.

As an escape it was small and brief but it left an impression.

I learned then or later that although we may wish for limitlessness, we may opt to cling to limits, choosing known unfreedom over the waterfall of unknown possibility.

In reading about Phoebe Snetsinger, I have discovered she did not actually pursue her bird passion fervently until a doctor diagnosed her with terminal cancer when she was fifty. The diagnosis was premature, and she ended up living nearly twenty more years, but it gave her the impetus and permission she needed. I hesitate to call illness providential, but sometimes it is the only way out when you are a mother, when embracing freedom from domestic expectations is perceived as irresponsible, even monstrously selfish. For Phoebe Snetsinger, melanoma was an appalling portal to a larger world.

By the time she died in 1999, at the age of sixty-eight, killed in a bus accident during a birding expedition in Madagascar, she had seen and recorded 8,398 bird species, more than anyone in history.

I don't know if Snetsinger's children resented their mother's frequent absences or the unquenchable passion that came to rule her life. What I do know is that three of the four are now bird researchers in the United States.

I recently found the photo of my mother and me standing by Niagara Falls. She is forty and dressed in a black blouse and a white vest, facing a complicated

middle age. I look uneasy in a pale yellow poncho. I look worried that I may billow over the falls. She is holding the back of my poncho with her hand. What I understood as a child was that she needed me close by and grounded. What I like to think now, as the mother I have become, is that she wanted us to take off together.

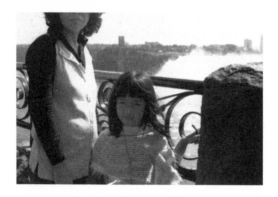

Now that the musician and I were both standing outside the aviary looking in, the birds were considerably less frazzled. A diamond firetail swooped into the birdbath. Another hopped on the food table. If we had turned off the lights, they would have gone quiet as if the sun had gone down.

The musician removed his nitrile gloves with a snap, tossed them into an overflowing garbage can. I followed suit. The finches were singing, and as the

music softened the room's hard edges, I noticed the musician's expression soften too. I could see he wasn't really angry at his father so much as concerned about the wrong-headed ways we approach the things we love.

For many years I told myself a story that painted my mother in tragic terms, as a woman who had made unhappy sacrifices, who had accepted wifely duty over artistic fulfillment. Within that mythology, the journey to and from the Falls became the emblem of my mother's capitulation and failure. I quietly blamed her for giving in, for not trying hard enough, for allowing her creative dreams to be thwarted.

But that was my story, not hers. It was a story that clung to an artificial vision of what it meant to be an artist, a story that allowed me to imagine myself as freer (better, stronger, less frustrated) by comparison.

In fact, the opposite may be true. Another story might be that my mother did not feel thwarted or locked out of opportunities or locked into obdurate habits or locked on to a quest that would require too much. At my age, she did not feel caged by the obligation to follow a passion that would not necessarily make her happy. She loved art but was fine without it. It did not mark her. There were long stretches when she lacked the time or inclination to look for beauty in the world, and that was okay. She didn't berate herself

or feel she had somehow failed or proven herself unworthy if she didn't feel like painting. She made her art lightly, suspending the pursuit of perfection. She made art when there was no one waiting for her to produce. She made art for herself.

The truth probably lies somewhere between these two stories.

My mother is a mystery to me. Between us is a barrier of language and disposition. She does not divulge or publicly introspect. She is easily riled, so I have learned to keep conversation breezy over weekly meals that I prepare. I will never know if there was a moment before the photo was taken when she enjoyed a kind of giddy happiness as she imagined a fresh start and a new life. I will never know where or what she was running towards and what clinched her decision to return, to keep living in the same house, the same life. Beyond her need to maintain appearances and stability, or some enduring tenderness towards my father, I cannot guess exactly what kept her.

Still, I have held on to this photo of us at the Falls as evidence. The photograph says: there will be times when an impulse to flee and a desire for freedom may tug at you and take you to the watery edge, the insoluble boundary between your needs and others' needs. Keep sight of the Falls.

I used to think that freedom was a hidden object. I stalked it through the house of my life, imagined that I would find it, rolled away under the bed, tucked there behind a chest of drawers.

I used to think that freedom was a simple matter of release, a door to be opened, the inside let out like a caged bird or a wish made true.

But not all birds choose to make great sky-loops of their freedom.

Now I know that the truth about freedom is that it's a practice and not a permanent condition. "It actually takes a daily effort to be free," writes Geoff Dyer in *Out of Sheer Rage*. Freedom is not a great leap or a definitive jailbreak or "the result of a moment's decisive action but a project to be constantly renewed."

What can you do within these narrow lines and this limited time? Who or what is stopping you?

When I look back on the time my friend and I ran away as teenagers, one thing stays with me: we ran as if we were being pursued, but if we had turned around we would have discovered that no one was following us. We had internalized our discipline and our jailers.

We were good girls who could not afford to believe that flight could be so easy, so unpunishable. After all, if there were no fixed obstacles, what but ourselves kept us in place?

The finches kept singing as we left the aviary. It was possible that they were singing for distant and unseen cousins in Australia. The sound travelled in all directions. It moved through and around objects. As we walked down the corridor, I could still hear it passing through the walls.

February

SMALLNESS

{
SWANS, DUCKS, COOTS,
SPARROWS, CARDINALS,
JUNCOS, CHICKADEES,
a CAROLINA WREN,
a BALD EAGLE,
and a
SCREECH OWL
}

On the satisfactions of small birds
and small art and the audacity of
aiming tiny in an age of big ambitions.

I work at

things

I try to do what the pigeons do when someone drops a loaf of bread to the ground and work larger pieces into a manageable size. I do this with tasks and crises. I do this with chores and meals I prepare.

The musician did this with nature.

His approach, enjoying small spots of nature every day rather than epic versions of wilderness and escape, made sense to me. Big trips were the glaciers, cruise ships to Madagascar, the Verdon Gorge, the Cliffs of Moher, walking on the moon. Small trips were city parks with abraded grass, the occasional foray to the lake-woods of Ontario, a dirt pile. Smallness did not dismay me. Big nature travel—with its extreme odysseys and summit-fixated explorers—just seemed so, well, grandiose. The drive to go bigger and further just one more instance of the overreaching at the heart of Western culture.

I like smallness. I like the perverse audacity of someone aiming tiny.

Together we would make a symbolic pilgrimage to the wellspring of the minuscule.

In February, the musician took me to a marina on the edge of the city. We pulled into a parking lot empty of cars but crowded with steel fences and heavy machinery, stacked-up docks and decommissioned porta-potties glittering with ice. It looked less like Arcadia and more like a scene out of *WALL-E*. This was not what I had pictured when the musician said "birding hotspot."

I followed the musician along the boardwalk to a wooded area by the lake.

A few moments later I was sitting on a rock on the beach surrounded by hundreds of resting mallards, blazing-white swans, and coots. The birds were huddled together for warmth, enjoying a frigid siesta. A resting swan tucked her beak into her feathers, just a few feet away from me.

The musician pointed to the swans on the lake, showing me how to distinguish between the trumpeter, mute, and tundra varieties. Then he went off to photograph a few coots.

Out of my element, I awaited instruction, trying to become one with the rock. And then, just like that, I settled in. The minutes and hours passed. A trumpeter swan retracted its neck and made a funny trumpet song. Three tundra swans paddled up and down the shoreline, a reflection of my own internal drift.

As the gaps between my thoughts grew longer, everything was changing. I imagined that I was on a fickle movie set—Bergmanesque starkness giving way to Tarkovskian fog as a grey mist crept in from the lake, blocking out the steel refinery across the water. The three tundra swans I had been watching grew dim. I looked down the beach and saw a figure, spindly in the distance: the musician materializing out of the blankness.

During a hike to warm up, we barely spoke because our jaws were stiff with cold. A male and female cardinal swooped past us and landed on a perch, their red and yellow bodies garish against the frugal winter backdrop.

On a dirt trail, the musician stopped to take pictures of a few juncos and chickadees, cooing like a pornographer—"sweetie, sweetie, doll, you look beautiful don't you." Snowflakes settled on our heads. Click, click, click. A few plump white-throated sparrows hopped into view. "*Sweetie, sweetie.*"

Hunkered down on the trail, the musician entered a tunnel of concentration, as snow spun around us. I imagined a sudden squall, a stampede of bison, a gang of wrestlers in metallic unitards, and knew that nothing would distract him. I went back to the car in the parking lot to warm myself. I adjusted the heat wraps I had velcroed around my torso that morning, layered a pair of woollen socks over my mittens. I hopped from foot to foot in intervals, singing "Get on the Good Foot."

Back on the trail, the musician held up his hand.

"There. Listen. That's it. The Carolina wren."

We caught a glimpse of the wren—a blur of rusty brown disappearing in a bramble—too skittish and quick for us to get a good look. A blink later, a juvenile bald eagle soared overhead. It was dark brown all over, still too young to have grown its distinctive white tail and head feathers. We followed it to the water where we watched a group of hooded mergansers with crests resembling Elizabethan bridal hats. They dove for barnacles while giant ice cubes clinked around them.

On our return to the car, a crowd of seven people was standing by a tree, telltale cameras aimed upwards. Resting in an elevated nesting hole was a tiny screech owl, labouring to sleep. Screech owls have intricately barred grey-brown plumage, an invisibility cloak that allows them to perfectly blend in with their surroundings. Hundreds of people could have passed within yards of that owl and never known it was there. But some sharp-eyed birder had blown its cover by sending out a message board alert. So, now, a storm of flashes.

"Attention is the rarest and purest form of generosity," wrote Simone Weil. But in that moment I could feel the musician's blood boil at all the ways we wrong birds with our interest. He put his camera away without taking a single photo.

Carolina wren

There were other people at the marina that day, not just the photographers. There were spectres on the misty beach and flitting presences as we walked. There was the woman who left birdseed at set points along the trail. She skulked past us, furtive in her Stevie Nicks–style hooded cape. When she left, I placed a bit of the birdseed on my outstretched hand and a chickadee landed. It weighed no more than an ounce or two. There were a few elderly birders. Bearded and sportily dressed, they approached us with tips, sidling up to the musician like scalpers or hash pushers at a Grateful Dead concert. "Tundra swan on the beach," they said. The musician seemed fine with this fleeting and peculiar intimacy.

Back in the car, we cranked the heat and headed home. We were both quiet, lost in our own thoughts. I was thinking that, with a few notable exceptions, the birding scene seemed pretty great. I liked the anonymous no-pressure camaraderie. This is what birds do when they join a swirl of other birds, I thought. They don't proclaim their individuality or try to make a splash. They dissolve into the group. I wondered if this merging felt so relaxing because it was an antidote to the artist ego, built on an endless need to individuate, to be *your own you*. In place of exhausting self-assertion, the relief of disappearing into the crowd.

I lifted my cup of coffee from the dashboard cup holder, took quick sips. I inhaled the smell of wet wool from the scarf double-wrapped around my neck.

A week earlier I had gone to see the musician perform for the first time. I arrived late, so I sat on a broken bar stool bracing my foot against the wall to reduce the wobble, while the room flickered under a slowly rotating disco globe. Pints of beer lined the bar. There were about forty people in the room. The musician was spiffily dressed in suit and tie. He grimaced, stammered, paced. I rocked on my stool, legs dangling, nervous for him but also curious. I knew he lived inside a world of music, that he could sit in his apartment listening to Gustav Mahler and The Band and playing his piano for hours. But I also knew he was full of artistic doubt, and that the equanimity he found while birding evaporated the moment he hit the stage.

His singing voice, sweetly hesitant, was unlike anything I'd ever heard. It felt like a miniature paper boat launched in a crowded wading pool: an intricate, crushable thing. His lyrics, rich in references to birds, ghosts, horses, sad families, scoundrels, and hope, had a raconteur's charm. That such a pure and trusting voice could emerge from a self-doubting man felt like magic.

On the highway, the traffic moving smoothly, our subject was ambition. The question for each of us: How much is enough? We were talking about the musician's new album. He was giving it the same name he gave his website, *Small Birdsongs*. It would be a suite of simple songs and he would play all the instruments.

"I like the idea of songs sung by those without big voices. You know, small birdsongs that rise above the noise of the city."

"I know, I know what you're saying," I replied.

If you pour everything into the tiny vessel of a song and wear out your heart, what is that? Is that small or big? If you choose to put yourself out there on a small stage, singing for the small somebody inside of you, knowing how quickly songs wane, is that modest or gargantuan?

Day after day I write my words at a small table in a small nook in a small café on a small street. On warm days, the doors are open. Sometimes house sparrows hop past or fly overhead. I don't know when I began to prefer small things. Drawings of the small moment, nearly microscopic sculpture, compact stories, animated shorts, airy novellas, little gardens,

economical studios, cozy dinner parties, small days of small demands that allow small increments of writing time.

And yet—I do not want my father and mother to grow small through the diminishments of age. I do not want: small that is cliquish or exclusive (i.e., available only to small numbers), small-mindedness or xeno-phobic smallness (the diminution of newcomers in the name of small-town values), or small-heartedness (emotional parsimony).

It is not about being perfect, delightful, and haute. Smallness with a big price tag or a shallow claim to virtuosity is not really smallness but rather, as Natania Rosenfeld points out in her lovely essay "In Praise of the Small," an "inverse of the monumental . . . grandiosity writ tiny." Call it pedestal smallness.

I may be guilty of ascribing purer intentions to the small. It is possible there's a feminist slant to my preference (and an explanation for why symbols of monumental and muscular vigour do not hold my attention). Or a Buddhist bent—a way of confirming my smallness in relation to the cosmos of other things.

"Many people are trying to recover a field of vision that is basically human in scale, and extricate themselves from dependence on the obscure forces of a global economy," writes Matthew Crawford in his cult book,

Shop Class as Soulcraft. "I think the world is going to be saved by millions of small things," said Pete Seeger a few years before his death in 2014. "Too many things can go wrong when they get big."

I recognize there is something of a defensive posture to smallness. Because I am the daughter of a bulk-buying hoarder (my mother), I prefer the mini to the jumbo. Because I am married to a fan of long, over-bearing opera of the Wagnerian variety, I tend to fetishize brevity and acoustic reserve.

My depleted attention span is also a factor. I am no longer very good with long movies or big books. The Sunday *New York Times* makes me anxious. Long ago, I sat through *Shoah* and read doorstoppers and listened to CD box sets, but at some point a culturally acquired laziness set in. I still love ample stories and long, winding sentences and characters that have psycho-logical bulk and emotional mass. But I would prefer to read Teju Cole's *Open City* over Marcel Proust's *À la Recherche du Temps Perdu.*

So now I try to make a case for artful compressions and the necessary intimacy of small-scale work where everything is not proportionately reduced. In *The Hare with Amber Eyes,* Edmund de Waal describes the netsuke in his hand as "a small, tough explosion of exactitude." How perfectly stated. In my experience, a work's external smallness can lead somewhere internally large.

But I am also willing to settle for an unexpected Instagram post, a funny comic. Littleness need not be deep to float my boat.

And of course I'm generalizing and there are things I enjoy that are wondrously big and very grand, such as the Pacific Ocean and certain glittering titanium museums and my close friend's big books of big ideas and my husband's big soulful singing voice. I admire largeness in others. I love Louise Bourgeois's mammoth "Maman" sculpture and Peter Doig's lush, anti-minimalist paintings. I enjoy the ambitious and epic, sometimes embarrassing films of Terrence Malick. I want to thank him personally for the enormous nerve he showed in *The Tree of Life*. When was the last time you were in the presence of a work that over-reached to such a glorious extent?

To some people, the desire to do small things and stay small may be perceived as a cop-out, a self-protective position or a form of pathological timidity and constriction.

Small is a safe harbour. The smaller your goals, the less likely you are to be deflated or "cut down to size." In this sense, a bias towards the small could be a version of low expectations. Or a form of feminized compliance, as in "I don't want to be seen as loud, fat, assertive, or ambitious."

Good girls are taught to make ourselves small until there is very little of ourselves left in the world, even as our hunger expands. If we are also "minorities," embracing smallness is a less mutinous and more predictable route. *Little, petite, modest, delicate, submissive, soft-spoken, docile, cute, feminine, tidy* ... Asian women are not assumed to be particularly magisterial, with the exception of Yoko Ono, who is frequently and predictably belittled for her artistic hubris and over-the-top voice.

When it comes to stature, we live in a contradictory moment. On the one hand, we have a digital culture that cultivates small celebrity. "We're living on a million tiny stages," notes *Portlandia* co-creator Carrie Brownstein. "Twitter, Instagram, Tumblr, Facebook, YouTube. Dinner plates are showcases for our food, beds become venues for our slumber, selfies are curtain calls for our faces. We put our activities on display, our feelings, our families, our skies." On the other hand, we have an economic growth model that assumes if you make something small (unless it is boutique and artisanal, and thus financially large or monumentally miniature), it is because you are somehow lacking and frail.

"Be more confident," my mother says, as if my literary "style" is a matter of low self-esteem and introversion (which may be partially true), a problem to be corrected through assertiveness training. "If only you wrote crime stories or stories about Leonardo DiCaprio or

how about a story about a cat that only likes to eat bananas." I once asked her what she thought of a picture book I had published (which she sat over—and even Googled—hour after hour, trying to divine its value), and she said, "It's a pity you didn't write a big book like _____. All my friends talk about *her*." She said this while trying to give me a large stewpot. We were sitting in her crowded apartment surrounded by objects from a lifetime of collecting.

That day she had already thrust upon me: a car-sized rice cooker, a three-pound bag of walnuts, and a giant pack of sports socks.

What bothers me is the unspoken assumption that not getting bigger is a form of arrested artistic development or failure. Contrary to my mother's belief, I do not wish to languish in obscurity and poverty. I am not trying to deny her boasting rights as an immigrant mother. I actually don't know how to make things bigger. Perhaps I lack the sheer egoism that George Orwell described as a writerly necessity in "Why I Write." But then what does "sheer egoism" look like to the Asian female writer? In response to Orwell, Deborah Levy writes: "Even the most arrogant female writer has to work over time to build an ego that is robust enough to get her through January, never mind all the way to December."

If I am guilty of hiding among tinier people in a tinier parallel world, it is because I am searching for other

models of artistic success. The small is a figure of alternative possibility, proof that no matter how much the market tries to force consensus, there will always be those making art where the market isn't looking.

A brief sampling of humans and avians praised for their smallness (a.k.a. the Pantheon of Smallness):

Sei Shōnagon (966–1017), Japanese diarist and poet whose brief and beloved *Pillow Book* bolstered an association between smallness and artistic quality in Japanese art and literature.

Rembrandt van Rijn (1606–1669), prodigiously talented Dutch artist who first earned his reputation for small-scale etchings, including a series of portraits of beggars and outcasts buffeted by bare white paper, noted for their unfinished and incomplete appearance.

Song thrush, speckled brown-on-cream breast, airy flutelike song with distinctive musical phrases.

Matsuo Bashō (1644–1694), Japanese haiku poet who often captured the tininess of human life in contrast to the vastness of nature, using the granular approach for sometimes grand insights.

Franz Schubert (1797–1828), Austrian composer who (in a short life) wrote six hundred lieder, later popularized by the famous mezzo-soprano Christa Ludwig, who said: "Schubert is so big, so delicate, but what he did was pick a form that looked so humble and quiet so that he could crawl into that form and explode emotionally, find every way of expressing every emotion in this miniature form."

Blackbird, glossy black-blue plumage, can sing two songs simultaneously.

Emily Dickinson (1830–1886), American poet who once described herself as "small, like the wren" and lived reclusively, transforming the minutiae of her life into poetry, and establishing a relationship to scale that placed "small" in the great category of atoms and the North Star.

Hugo Wolf (1860–1903), Austrian composer famous for his intense, theatrical song miniatures, which have been called "mini-masterpieces."

Nightingale, plain brown, reddish tail, secretive, famous for its beautiful night song.

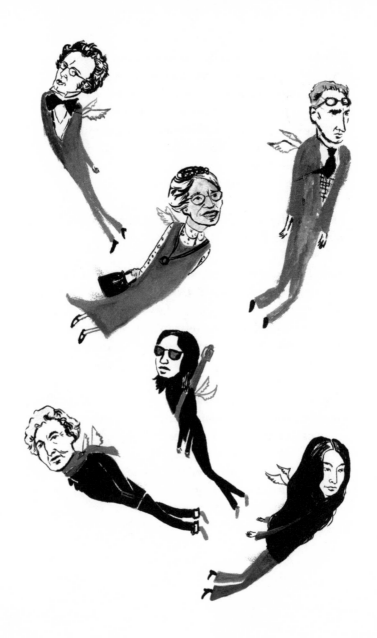

Robert Walser (1878–1956), German-speaking Swiss novelist who once gave a character the motto "To be small and to stay small" and who, when later institutionalized for mental illness, became famous for writing his "extraordinarily delicate" prose in nearly microscopic script.

Paul Klee (1879–1940), Swiss-German painter celebrated for his ambitiously miniature paintings, which he infused with music, mystery, graphic charm, and bursts of wicked humour.

Black-capped chickadee, oversized round head and tiny body, very curious, simple whistled song.

Giorgio Morandi (1890–1964), Italian painter celebrated for his small-scale and humble still lifes (mostly vases), who expressed great rigour and passion in a practice shaped by subtlety and self-restraint.

Elizabeth Bishop (1911–1979), American poet with a small oeuvre but sizable reputation, who said: "Why shouldn't we, so generally addicted to the gigantic, at last have some small works of art, some short poems, short pieces of music . . . some intimate, low-voiced, and delicate things in our mostly huge and roaring, glaring world?"

Purple finch, deep pink "raspberry" head, treetop forager, warbly song.

Tillie Olsen (1912–2007), American author of *Silences* whose tiny handwriting and small output belied her large concern for those written out of literary history—the "diminished, excluded, foundered," those so small you would never hear of them.

Rosa Parks (1913–2005), African American civil rights activist who refused to give up her seat on a segregated bus, a small gesture that sparked a mass movement.

Song sparrow, russet and grey with bold streaks, stuttering song.

Pete Seeger (1919–2014), self-effacing grandfather of American folk music and proponent of small political actions whose songs often addressed small unsung lives and gathered little voices into roof-raising choruses.

Maurice Sendak (1928–2012), peerless American illustrator-author of children's books who told PBS in a 2004 interview that he chose this modest form in the 1950s because he didn't have much confidence in himself. "I wasn't gonna paint. And I wasn't gonna do ostentatious drawings. I wasn't gonna have gallery pictures. I was gonna hide somewhere where nobody would find me and express myself entirely."

Yellow warbler, bright egg-yolk yellow, sweet whistled song performed from high perches.

Yoko Ono (1933–), Japanese-born artist who in 1964, before meeting John Lennon, collected her tiny meditations on the big imponderables of life into a small book called *Grapefruit* published in a limited edition of five hundred, and whose singing style put the lie to the notion that Asian women are non-threatening and meek.

Sixto Rodriguez (1942–), Mexican American singer known for his disarming modesty and humble lifestyle who had no idea his album was a huge hit in South Africa or that he had played a role in galvanizing anti-apartheid activists.

Junco, generally dark grey with bright white tail feathers, singer of short trills and quiet tunes.

Slinkachu (1979–), a London-based photographer known for creating miniature street installations using tiny figurines—which he leaves to the mercy of roadsweepers, heavy-footed pedestrians, and city beasts.

Minutemen (1980–1985), an American punk rock band named for the brevity of their songs, they believed in "jamming econo" as a response to the corporate greed and mass consumerism of Reagan America.

Goldcrest, England's tiniest songbird, weighs just a quarter of an ounce at full size, sings a very high-pitched song that many people are unable to hear.

We were almost home from the marina, on the last stretch of road into the city, when I asked the musician about posterity. I was thinking back to his bar performance and wondering, given his stage shyness and aversion to self-promotion, if he ever thought about things like his "legacy" or the idea of making "art for the ages." I wanted to know: Was it enough to sing small songs that rose to the surface for a moment, shared then gone? What about everlasting glory? Didn't he want a smidge of that?

Although it was clear he did not dream of being a megastar, I sensed that he would be disappointed if his music went entirely unnoticed. Neither the musician nor I were whispering down wells or writing words to be kept in a drawer or buried underground.

He smiled and after a moment said: "You know, sometimes I like to think about all the stuff people have ever made—the vast history of beautiful songs and books—sitting on the shelves of a giant library, say the Library of Congress. I picture stacks of shelves from floor to ceiling and imagine all the artists that I love with a shelf of their own. Maybe Glenn Gould would have two shelves. Maybe another artist would be right near the top with three shelves. Then I think:

what I want is a tiny spot on a shelf. A few inches of space. It doesn't matter where. Maybe in a corner. That would be nice."

I nodded: a little spot alongside all the gifts of the made world. A dream, and maybe not such a small one after all.

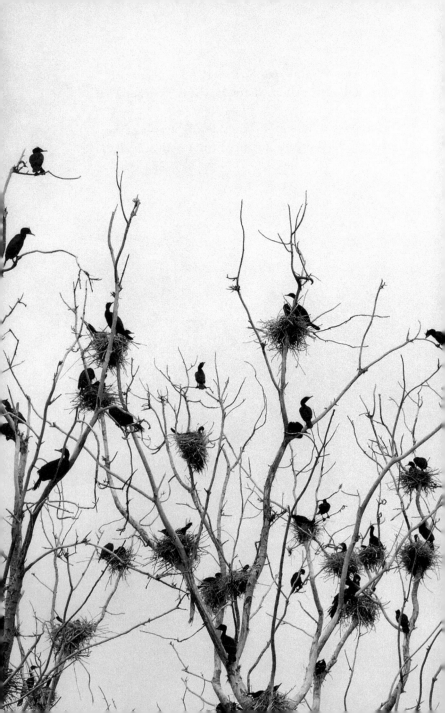

SPRING

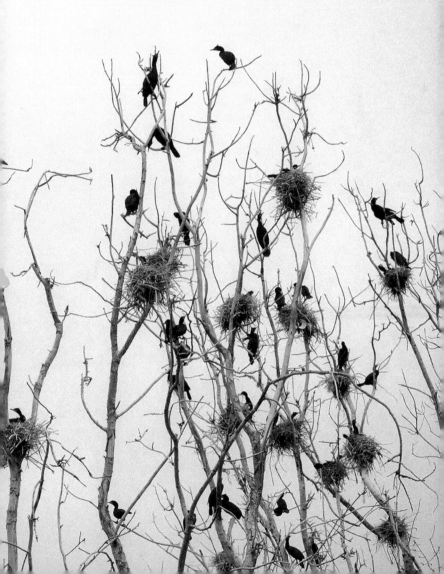

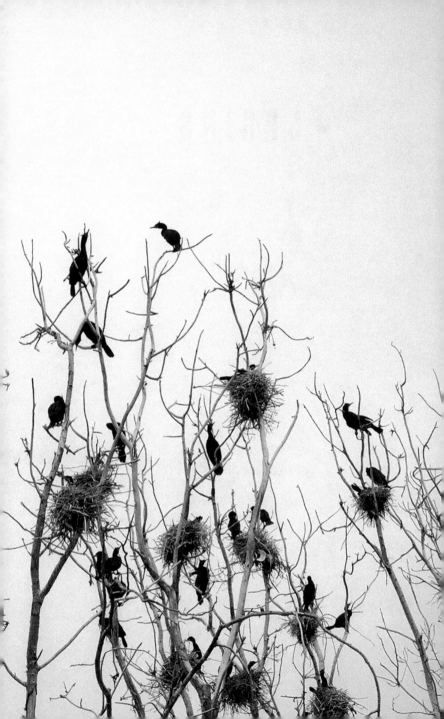

March

WAITING

{
a HORNED GREBE,
a COOPER'S HAWK,
and a Solitary
WESTERN GREBE
}

On the frustrations and unexpected rewards
of waiting—for birds and inspiration.

When I waited it was early

spring: Green snowdrop shoots and the first show of crocuses. It was a time to feel optimistic, and yet somehow I felt the opposite. The musician and I were sitting in a booth at a family restaurant in High Park. The weather the past few weeks had been grim. The dirty walls of snow lining the streets had begun to thaw. Now the roads were filled with a substance that resembled grey margarita mix.

Usually I enjoyed our conversations, wide and sprawling and lingering. Friendship is lingering. You need that sense of time and timelessness that hanging out with friends requires, so it was not surprising that in recent years I was drawn to younger men, usually a few years younger, who did not have family obligations and who did not feel every minute—every second— needed to be accounted for.

But at that moment the musician was on a detailed tirade about some person who had annoyed him on a birding message board. A person I did not know, whom I would never meet. I leaned back, waiting for him to finish, falsely patient, unsticking my stare from the sugar dispenser, noting the silent sweep of the clock hands on the wall ahead of me.

It was an exhausting reminder of the realities of personhood—the discovery that the musician would have turbulent and tedious moods like the rest of the world, that I would be a sullen and impatient friend and actually have no idea how to "linger" without agitation.

Feeling time acutely, I rushed from the restaurant to pick up my eight-year-old son from school. Despite my last-minute dash not to be late, I was late.

In those ten minutes of waiting, my son had fallen on jagged ice and gashed his chin open. I found him walking by himself across the frozen field dragging his heavy knapsack behind him. I did not see the blood from a distance but I could see right away he wasn't walking normally. He was walking *tragically, dazedly*, like a novice pilot who had just crashed his plane in the middle of an arctic wasteland. I ran over and crouched down with him in a huddle to assess the wound while he moaned and his tears plopped on the ground.

Because it was a deep cut, I scooped him up and we

went to the nearest hospital. My son's moaning, which had briefly escalated to ungodly shrieking in the confines of the car, subsided the moment we passed through the door into the crowded ER entrance. He had been here before and he knew the drill.

Dusty alcohol smell, triage nurse with glittery blue eye makeup and opulent bosom, burnt-orange vinyl chairs, teenage boy with broken ankle and scar under one eye cramming a chocolate bar into his mouth, skinny girl holding a skinny purse, white-haired woman with patch on her eye, middle-aged man in wheelchair drinking orange juice from a very long straw, TV screen playing *The Fresh Prince of Bel-Air*, custodian endlessly wiping the floor clean, the indescribable yellow-beige wall colour ... The hours passed and we invented new sitting positions and our stomachs growled and we grew parched. We ate the almonds I kept in my knapsack. Then we raided the vending machine for Snickers and Sun Chips.

My son grew sleepy. His nervous but ready expression softened into boredom as he sprawled across my lap, folding his hands under his cheek as a pillow. I told him I was sorry for being so late to pick him up. "It shouldn't have happened," I said. He looked up at me as if he had no idea what I was talking about. I gathered up his arms and legs until he was folded in my arms like a futon. An inebriated woman who looked like she had recently lost a fight with a wall was smiling affectionately at us. Her nose and forehead were bruised and bandaged, and her mouth was an impasto of rust-

coloured lipstick. I smiled back. The room was crowded with people. We all had this waiting in common.

My son's name was called. Lulled by exhaustion and the ER doctor's slow, reassuring voice, he submitted to a freezing needle with only a modest groan. I held his legs while the doctor sutured his chin, tugging on the frozen skin, and held his hand when he bid the ER staff a peppy farewell. ("See you soon!" he said. "We hope not!" they replied.) He was experiencing an endorphin rush and a flash of nostalgia. It was his second bad fall in six months, his second round of stitches, and both times there had been no momentum behind the fall. He had just fallen.

Later, I was lying in bed, 12:40 a.m., when I heard my son downstairs, flicking all the lights on. "I am worried," he said when I came down to gymnasium brightness. "I don't want to keep falling." I remembered I had a small sack of Guatemalan worry dolls and found them in my jewellery chest under a stack of unopened envelopes. My son is a believer in special remedies. I handed him three tiny dolls in tiny costumes, which he cradled in his hand, whispering a single worry to each doll. After getting him back to sleep, I lay in bed thinking of those unopened envelopes, seven in total, given to me by my father over the course of twenty years of hospitalizations. Each one contained everything I would need to know, everyone I

would need to contact, *just in case.* I whispered a single wish to each one. *I wish you were a love letter, I wish you were a ticket to Italy . . .*

> Nothing happens, nobody comes,
> nobody goes, it's awful.
> SAMUEL BECKETT, *Waiting for Godot*

Waiting for a late friend. Waiting in line at the movies. Waiting for the phone to ring. Waiting for the mail. Waiting at the checkout counter. Waiting in traffic. Waiting for the train. Waiting for the plane. Waiting in a darkened theatre. Waiting in a foreign country. Waiting to give birth. Waiting for sluggish minors. Waiting for elderly parents. Waiting for something to go wrong. Waiting at the doctor's office. The waiting of chronic illness. Eroded public services waiting. Waiting for the Messiah. Waitlist waiting. The hoping and waiting, the waiting and hoping. The waiting of childhood. The waiting to grow up. The waiting of old age. Waiting to recover. Waiting for another stroke. Waiting for the body to let go. Waiting for inspiration. Letting-the-field-lie-fallow waiting. The thinking-of-nothing-and-thinking-of-everything waiting. Waiting just as the storm ends. Waiting for the sun.

The musician and I met again at the end of the month. We arranged to go to a park along Lake Ontario created on the grounds of a former psychiatric hospital. There was a "hot ticket" bird, and the musician thought it would be a special treat. The air was damp and soft. Heavy clouds drifted across the sky. It happened to be my birthday.

"What I'm looking for," the musician told me, "is an accidental bird." "Accidental," he explained, is a way of describing solitary birds that have lost their way. For birders there is nothing more compelling than a bird in the wrong place or in the right place at the wrong time. The bird we were after was a western grebe, a water bird common in the North American West but rarely seen in Ontario.

I was stirred by the idea of an accidental bird. Could it be a harbinger of doom indicating climate change, potentially catastrophic to the species? Or was it just a rebel bird with a bad sense of direction and an aversion to flock formation?

We sat by the edge of the marina bay, under the paper-coloured sky, a din of rush-hour traffic in the background, as the grebe floated in the middle of two distant banks. Even far away, it was one of the prettiest

and most elegant water birds I had ever seen—slender with striking black-and-white plumage. It reminded me of Pina Bausch, long dark hair tied behind her graceful neck. A dancer's commanding sleekness.

We waited for it to come closer.

And waited.

And waited.

It was hard to decide which side we should be on. This side or that side. We tried one side, then seeing that the grebe had floated closer to the other shore, we made the twenty-minute hike around to the other side. By this point, the grebe was closer to the other shore.

So we waited and waited some more. We sat on the rocks, then on the grass, the sky empty above us, hour after hour. The musician was effortlessly still. My own stillness had the quality of intense effort. If we were in the Stillness Olympics, I thought, the musician would own the podium.

A little wind whistled along the bone of my ear. More people arrived to see the grebe. When there is a hot-ticket bird, the musician explained, word of its presence will speed along the various communications networks that link bird enthusiasts all over the continent.

Twenty years ago, if you saw an unusual bird, you might mention it to the person passing you in the park, vaguely motioning towards its location. Now, with mobile phones, bird alerts have GPS precision. A birder in Savannah, Georgia, can learn of a "drab

female cerulean warbler at 89th Street near Central Park" mere moments after it is sighted.

By late morning the edge of the water was dotted with people looking through binoculars, spotting scopes, and cameras set on tripods. A few non-birders cupped hands around their eyes, trying to spot the celebrity. Where did all these people come from on a working day? Was it really worth waiting for hours on a barren breakwater for a fuzzy photo?

A Cooper's hawk with a dark-banded, white-tipped tail flew over our heads. A horned grebe sporting a punky Klaus Nomi hairdo put on a little show, diving and disappearing. The musician and I tried to guess where it would resurface. There. Or there. Or maybe there. It was a fun, leisurely game. It was not a game for a busy, gainfully employed person. But we had long ago shed our busyness.

The basic measure of time, the tempo around which we arranged ourselves, the water lapping, the sky slowly changing from paper white to cobalt blue, was the tempo of boating retirees. Or maybe it was the tempo of firebrand revolutionaries on a wildcat strike against industry. Either way, we were Not Working. We had desynchronized from productive time frames. My chronic sense of being late for some appointment dissolved.

I heard the clicking of the musician's shutter and looked up to see the western grebe stretching and spreading its wings. Then the western grebe retracted its wings and went back to floating.

According to *Webster's* dictionary, the word *wait* means to stay in a place of expectation, to not do something until something else happens. To wait means to remain stationary in readiness. The etymology of wait is to look upon, to be attentive, awake.

To wait is to be close to nothing, to *feel* that closeness to nothing and to have confidence that it is more than that.

The hardest adjustment for new birders is the waiting without itinerary or guaranteed outcome. Rachel Cusk captures this feeling of queasy idleness in her novel *Outline* when she describes the "great sense of futility" and the "feeling of some malady" which is "really only the feeling of stillness after a life of too much motion." Most of us don't have time for the malady of stillness. Life is too short for longueurs. The idea of sitting for hours on end, on rocks or bits of log, in the cold, for a bird, is the definition of lunacy and silliness.

And yet—"Time has a different meaning for birders." So said the legendary New York City birder Starr Saphir. Known as the birding doyenne of Central Park,

Saphir led walks four times a week for nearly forty years (once, memorably, including Conan O'Brien). Each eight-dollar tour lasted five to six hours—which meant long stretches of waiting. The tours continued even after Saphir was diagnosed with metastatic breast cancer in 2002, even when she needed to pop painkillers to keep going. ("At the end of every walk, I can barely get myself home, and I just kind of collapse into bed," she admitted.) Aware of her finite days, the accelerated hourglass of time, she still walked and waited with infinite patience. Maybe the waiting helped slow time. She lived until 2013, surpassing her doctor's prognosis.

What makes waiting painful is the desire and goal to not be waiting. I had this epiphany one day at the dentist's office. The dentist was delayed in surgery and as time passed inexorably the dental hygienist said that I was the most patient patient she had ever met. She marvelled at the way I lay there motionlessly, draped in the dentist's chair like a boneless human. "I am a new mother," I said. She nodded knowingly.

Reclining in that chair—on pause from nursing, thinking, speaking, doing—I realized: It is sometimes painful to wait. But it is also painful to always be in a hurry on someone else's behalf, to cram as much into a day as a day allows.

The musician and I went for another short walk to stretch our legs. It was getting colder and our breath came out in small white clouds. When we returned to our sitting spot, the western grebe was still floating in the distance, oblivious to the attention it was generating, enjoying its own noonday rhythm, the bird equivalent of "moseying along."

Keep awake and wait. And wait. I was learning. What I was learning was tacit and ordinary, but I sensed it was very important nonetheless. It was about how to be a birder and maybe more. It went something like this:

If you hope to see something, especially the notably elusive, you will learn to wait, like a devotee or a sanguine lover. You will choose your sitting spot and then you will just sit there. You will sit there, in the wind or drippy cold, waiting for the possibility of something beautiful to appear.

You will discover that the magic of a sitting spot is that it teaches you to go nowhere. If you are lucky, it will bring birds closer, or you closer to noticing them. You will sit so long that you eventually become part of the baseline conditions of a place.

If you grow restless, you will resist the childish temptation to run into a crowd of ducks or sparrows so you can watch the explosive liftoff. You will restrain yourself with the knowledge that any time you make an "abrupt, heedless, uncaring" gesture in a given habitat

you risk creating what naturalist Jon Young calls a "bird plow." This is not only annoying; it is potentially life threatening. Birds that have wasted energy lifting off and landing in a strange area are vulnerable to animal "wake hunters" who may seize on the opportunities caused by their fright and confusion to attack.

The goal in birding, you will discover, is to become as quiet and invisible as possible, and the easiest way to do this is to stay in one place, minimizing your wake of disturbance. When you stop with your fast movements, your sudden noises and unnecessary fidgeting, the birds (even the nervous perching varieties) may begin to respect you, by which I mean ignore you.

Even though you will inevitably discover that not everything within the spectrum of human desire is instantly available to you, your patience may be rewarded. You will encounter the reluctant and well-hidden things. These things may be fleeting and fading and without any obvious payoff, but you will discover that the realm of birding is also, sometimes, the realm of miracles.

♪

Don McKay (Canadian poet and avid birder): "All you can do is make sure you're in the right habitat."

Neil Young (Canadian singer): "I don't try to think of [songs]. I wait till they come ... If you're trying to catch a rabbit, you don't wait right by the hole."

Annie Dillard (American author): "Beauty and grace are performed whether or not we will or sense them. The least we can do is try to be there."

The musician and I packed up to leave. Two dozen people remained along the barren breakwater, serenely waiting for something that might never come. I admired their determination and the maverick force of their "project," which ran so counter to what the rest of the world was doing. They were not furthering the economy of the city. They were going against its whole momentum.

Just before we said goodbye, the musician gave me my first bird book, a 1967 edition of Roger Tory Peterson's *A Field Guide to the Birds*. It was a blue hard-cover, wrapped in stiff cellophane. It was a beautiful edition, and I held it carefully and maybe a little warily, as though touching a book that stored all the many things I'd never known to wonder about before.

April

KNOWLEDGE

{
a RED-WINGED BLACKBIRD,
a HOUSE FINCH,
ROBINS,
WOOD DUCKS,
a KINGFISHER,
a CHIMNEY SWIFT,
a BLACK-CROWNED
a NIGHT HERON,
an EGRET,
SONG SPARROWS,
WHITE-THROATED SPARROWS,
HOUSE SPARROWS,
and a GADWALL
}

On the utility of books in the real world and
the allure of really knowing something.

My earliest bird memory

is of the pigeons in Trafalgar Square. I remember standing by Nelson's Column with a fistful of bread surrounded by a sea of ravenous birds. I was four years old. I remember my pixie-haired nanny demonstrating how to scatter the crumbs. *Like this,* she said, *a delicate toss.*

After we moved to Canada, I remember the small birds that used to fall to the ground outside my school. It was a quiet, leafy neighbourhood known as Forest Hill. They zipped through the air and flew into the Gothic glass windows, mistaking the glass for a clear path. I quickly learned the specific sound a bird makes when it smashes into a window. I learned that when buildings and birds collide, the buildings always win. The birds dropped to the grass like little sacks of sand. We would come out to play and find a few cinder-coloured bundles at our feet right under the oak trees. I remember their little matchstick legs poking up at the sky. Sometimes there would be a trickle of blood, but usually they would just look like they were napping. I left that school after two years, so I don't know if they ever learned to curtain the windows or if they ever placed a deterrent image on the glass as some buildings have done. But I remember thinking it seemed cruel that a bird should be punished for believing it could fly.

I remember the crows in Yoyogi Park. I was eighteen and walking through Tokyo with my Canadian boyfriend. I remember how the crows suddenly darkened the skies. I remember the way they screamed as they dove down and with their beaks tore open a garbage bag a few feet away from us. I remember the whoosh of their wide wings and their claws, which looked like cartoon witch hands. I began to cry from terror. I knew they sometimes attacked unsuspecting pedestrians who moved too close to their nests. They were savage. They would peck out the eyes of creatures that were still alive. At least vultures would wait until you were dead.

Growing up, I spent every summer in Tokyo, and the crows had always frightened me. They are known as jungle crows, and to find them in the heart of an immaculately groomed city was both fantastical and terrifying. It hinted at a wild and unruly reality that might be hidden beyond tidy streets and gleaming facades.

There may have been other birds outside my grandmother's house but I don't remember them. What I remember is spending a lot of time inside. I remember how the shoji screens would filter sounds from the outside world—the sound of trucks with their loudspeakers, those selling roasted sweet potatoes and the ones selling right-wing politics. I remember the soothing sound of rain cascading down the brass rain chain from the roof gutter. Rainy days were

for writing letters to my friends who had migrated north to summer camps in Ontario. Rainy days were for reading.

When boredom and loneliness threatened to swallow me up during my long summers in Japan, I would retire to a small room in my grandmother's house, unroll a futon, turn on the fan, and read, thus inaugurating a lifelong passion for books.

I escaped. I went to the English and Welsh countryside with the Famous Five and to New York with Claudia and Jamie Kincaid. I time-travelled and shape-shifted. I lived in the Jurassic past and the atomic future. I lived in Macondo and the Republic of San Lorenzo. I lived as a prairie girl and a French detective. I lived in dire Dickensian poverty and great dynastic wealth.

Books were my steadiest companions. When I ran out, I went downtown to Shinjuku and bought Japanese novels in translation. Sōseki. Tanizaki. Oe. My books formed a nest around me on the tatami mat, right near my aunt's Buddhist altar. A waft of sandalwood as the incense sticks burned.

They were my life and narcotic. They were "alive and they spoke to me," as Henry Miller wrote. "With childhood reading there is a factor of significance which we are prone to forget—the physical ambiance of the occasion. How distinctly, in after years, one remembers the feel of a favorite book, the typography, the binding, the illustrations, and so on. How easily one can localize the time and place of a first reading.

Some books are associated with illness, some with bad weather, some with punishment, some with reward.... These readings are distinctly 'events' in one's life."

I was a bookish child and grew to be a bookish adult. Books gave me pleasure but they also gave me permission to isolate myself, to turn away from the world when it bothered or frightened me. Books allowed me to hide from demands, from the day, from family and the immediate world. They provided solace and amusement in the deep night and served as surrogates for friendship when I was far away from home.

Susan Sontag, remarking in one of her journals on her inability to stop reading, even in the face of her terminal illness, wrote: "I can't stop reading.... I'm sucking on a thousand straws." I know that feeling of bottomless hunger for words, even and especially during times of crisis. When I read Sontag's words I thought of the famous photograph showing the ruins of a London bookshop following an air raid in 1940. It shows men browsing the shelves after the all-clear sounded—a showcase of British perseverance or, perhaps, unstoppable biblio-addiction; a sign of folly or unvanquished hope.

Books have given me great stores of happiness, but if I am honest with myself I can see they have also taken something away. I glimpsed the real world between paragraphs of novels. I traced words when I might have touched the ground.

From those days in Japan, I still imagine a wheaty waft of tatami every time I open a book. I also have an

inability to read upright. To fully immerse myself in a book, I must be reclining. I read best when mummified in blankets.

Sometimes books have housed me and sometimes they have encased me.

Although I have consumed vast numbers of books, I still feel entirely ill equipped in most practical situations—such is the vicarious nature of reading. Books have introduced me to world religions, ancient civilizations, political movements, the traumas of modern warfare, legal theory, the history of art, and theories of the unconscious. They have expanded my powers of empathy and insight. But I still do not know which berries are poisonous or how to predict the weather, stanch a wound, or build a fire without matches.

It's arguable I've just read too narrowly. There are many bookish people in my life who know how to do practical things, how to be in the physical world. Simon can bake bread. Jason can build a house. Hiromi knows how to forage in the woods. Jude knows how to make a poultice. Susan can make cordage out of tree bark. Sasha can deliver a baby. Some of this knowledge may have come from books, but I suspect much of it was acquired slowly and osmotically, through field observation and long conversations, through trial and error, contemplation and silence.

Some days when I feel alone in my unknowing I

wonder what others know. Walking around my neighbourhood, I see bearded men who resemble woodsmen in their vintage lumber jackets and willowy women who resemble homesteaders in their prairie dresses. They look like they are heading off to swim logs down streams and pick flowers in vast grasslands. They look like they would know words like *brook, buttercup, heron, ash, beetroot, bray, bridle, gooseberry, raven,* and *catkin.*

In 2007, the Oxford University Press eliminated from its *Junior Dictionary* a number of words associated with nature. Among them were the names for thirty species of plants and animals—such as *acorn, blackberry,* and *minnow.* These words were replaced with up-to-date terms like *analogue, broadband,* and *cut-and-paste.* In 2015, a group of international writers issued an open letter asking for those words to be reinstated.

> We base this plea on two considerations. Firstly, the belief that nature and culture have been linked from the beginnings of our history. For the first time ever, that link is in danger of becoming unravelled, to the detriment of society, culture, and the natural environment.
>
> Secondly, childhood is undergoing profound change; some of this is negative; and the rapid decline in children's connections to nature is a major problem. . . .
>
> We recognize the need to introduce new words and

to make room for them and do not intend to comment in detail on the choice of words added. However, it is worrying that in contrast to those taken out, many are associated with the interior, solitary childhoods of today.

The musician knew things. This was clear to me very early on. Even when he behaved like a flighty artist, I still knew that as a part-time landlord he knew how to fix a fridge and do basic electrical work. It was also clear that as a birder, he was no dabbler. He always knew exactly where and when to go see birds. He knew what those birds would be and usually he knew why and how they got there.

Not that he advertised his knowledge. The musician was interesting and anecdotal, humorous and helpful, but as a guide, he wasn't very guiding. The Roger Tory Peterson book he gave me for my birthday was the first gesture he ever made towards explicitly educating me.

This was fine with me. At least for the first few months with the musician I was happy to know very little. I did not look things up, turning away from my book-bound life. I liked the idea that I was having a pure, unfiltered experience. I was an empty slate. The skies and trees were my school.

It was all very romantic, but it was also untrue. Actually, I did know things. My bird knowledge came with me every time I went out for a walk. It was

confected of pop songs, poetry, mythology, garish nature postcards, IMAX movies, Warner Bros. cartoons, Froot Loops commercials, European master paintings, and homemade crafts. I was steeped in pop ecology. I had learned about blackbirds from the Beatles and the mechanics of flight from Tweety Bird. My history of acquired bird information could not be cancelled out simply because I wished it to be.

What happened in those first few months with the musician was a form of shedding. The more I encountered the reality of birds, the more my second-hand impressions of "birds" began to fall away. When we sat together in a swirl of mist and formless time, when I stopped seeing my idea of trees and started seeing infinite shades of green, when I looked at a swan's back and saw that each feather was an intricate masterpiece of white, when distances collapsed and my own sense of scale diminished, it was a moulting.

Then the musician injured his knee. It happened in early April and it was serious enough to make bird walks impossible for a while. To fill the time, I decided to read. I came across a quote from Walker Evans on the musician's website: "Die knowing something." Suddenly not-reading seemed like a stupid and lazy thing to do.

I borrowed a stack of books from the library. There were books on the bone density of birds and the

musculature of flight, books with sonograms, graphs, and accounts of various laboratory inspections and dissections. I consulted these books quickly, then returned them. These books had too much information and I had made myself a promise: I would not read out of duty, only pleasure. I wanted John Fowles's woods knowledge: "a kind of wandering wood acquaintance, and no more; a dilettante's, not a virtuoso's; always the green chaos rather than the printed map."

Manual of Ornithology: Avian Structure and Function by Noble S. Proctor. *Ornithology* by Frank B. Gill. *The Unfeathered Bird* by Katrina van Grouw. *The Inner Bird: Anatomy and Evolution* by Gary W. Kaiser.

I borrowed more books. There were older books by amateur ornithologists and weekend naturalists. I begin to understand why many people remain wary of nature writing. It's all that romantic wandering and dumb-struck waxing on; all those sublime mountains, delicate flowers and shimmering sunsets. There is simply too much effusion, passion, and love for our ironic age. Even my environmentalist nature-loving friends avoid it.

Portrait of a Wilderness by Guy Mountfort. *A Twitcher's Diary: The Bird Watching Year of Richard Millington.*

I borrowed more books. Despite a desire to remain open-minded, I was fighting my prejudices. I judged books by their covers. I judged them by the dull and distinguished-looking authors who looked as if they had just returned from wind-tossed heaths. I judged them when their first pages were sickly sweet or deadly dry. I grazed and sampled.

The Bird Collectors by Barbara and Richard Mearns. *Songbird Journeys* by Miyoko Chu. *Living on the Wind* by Scott Weidensaul. *Kingbird Highway* by Kenn Kaufman. *John James Audubon: The Making of an American* by Richard Rhodes. *Where Have All the Birds Gone?* by John Terborgh. *Birds Britannica* by Mark Cocker and Richard Mabey. *Birding on Borrowed Time* by Phoebe Snetsinger. *How to Be a Bad Birdwatcher* by Simon Barnes. *Providence of a Sparrow: Lessons from a Life Gone to the Birds* by Chris Chester. *Grass, Sky, Song: Promise and Peril in the World of Grassland Birds* by Trevor Herriot. *Nature Cure* by Richard Mabey. *The Running Sky* by Tim Dee. *On Extinction: How We Became Estranged from Nature* by Melanie Challenger.

I gathered seminal field guides to North America. Smooth pages. Straightforward glossaries and no-nonsense grids. I loved these books for their biblical heft and diagrammatic certainty.

The Sibley Guide to Birds by David Allen Sibley. *Collins Bird Guide* by Killian Mullarney et al. *A Field Guide to the Birds* by Roger Tory Peterson.

The books tended to fall into two camps: birds seen by scientists/taggers and birds seen by poets/roamers. It was the latter that tended to sweep me away, but because these books were so voice-driven, questions of subjectivity and entitlement rushed to the fore: Who was doing the roaming? Who was boldly going forth, mostly alone and untrammelled? Was it the "Lone Enraptured Male" Kathleen Jamie famously pilloried in her *London Review of Books* essay? ("What's that coming over the hill? A white, middle-class

Englishman! ... From Cambridge! ... Quelling our harsh and lovely and sometimes difficult land with his civilised lyrical words.") Despite a twenty-first-century veneer of self-awareness and cosmopolitanism, it was often the same old gents on spiritual quests.

The Peregrine by J. A. Baker. *The Natural History and Antiquities of Selborne* by Gilbert White. *The Old Ways: A Journey on Foot* by Robert Macfarlane.

The tone varied widely. There were breezy conversational books full of corny humour. There were quiet, austere books that had been blurbed and praised by quiet, austere magazines. The books I liked most were the shorter and warmer ones, the ones built on personal stories that did not assume access to rural traditions that were dissolved for many of us ages ago. The books I liked tended to emphasize the smaller wildnesses in the non-pristine places in which most of us actually live. "Between the laundry and fetching the kids from school, that's how birds enter my life," wrote Kathleen Jamie in *Findings*. Many of these books were written by women for whom the focus on the close and domestic rather than the far-flung and epic was often a necessity.

The Greater Common Good by Arundhati Roy. *Flight Maps: Adventures with Nature in Modern America* by Jennifer Price. *To the River* by Olivia Laing. *Corvus: A Life with Birds* by Esther Woolfson.

It made sense to me—the focus on the nature growing in the cracks and crevices of urban life—not because we should romanticize human blight and

fallout but because, at the end of the day, humanized nature is all that many of us have.

I began to appreciate the books that were more plainly science-minded rather than piously inspirational. Poetry captures the elusive nature of birds, but it is science that allows us to see them with precision and grace. The best books captured the sweet spot between poetic not-knowing and scientific knowing.

The Wisdom of Birds by Tim Birkhead. *What the Robin Knows* by Jon Young.

I liked learning specific things. For example, from *The Bird Detective* by Bridget Stutchbury, I learned that birds around the world have adapted their singing behaviour. The ones that live in urban areas have changed their songs "so that the notes are not masked by background human noise." Adjusting their tunes "opportunistically" allows them to rise above the din of city life. When the culture is noisy, one way of adapting is to big it up.

From Olivia Gentile's *Life List*, I learned about "spark birds." A spark bird could be as bold as an eagle, as colourful as a warbler, or as ordinary as a sparrow, as long as it triggered the awakening that turned someone into a serious birder. Most birding memoirs begin with a spark bird.

Eastern phoebe—John James Audubon (As a young boy living in Pennsylvania, Audubon tied silver thread around the legs of several young birds, hoping to discover if they returned to the same nest every year. The following spring, two returned with "the little ring on the leg"—so inaugurating the practice of bird-banding in North America.)

Northern flicker—Roger Tory Peterson (It was lying on the ground. "I poked it and it burst into color, with the red on the back of its head and the gold on its wing. It was the contrast, you see, between something I thought was dead and something so alive. Like a resurrection. I came to believe birds are the most vivid reflection of life. It made me aware of the world in which we live.")

Blackburnian warbler—Phoebe Snetsinger (Spotted in the woods of Missouri, the songbird with its flaming orange throat "nearly knocked me over with astonishment—and quite simply hooked me forever.")

Magnolia warbler—David Allen Sibley ("My father, an ornithologist, had trapped and banded this incredible black and grey and yellow and white bird, this little feathered jewel. . . . We took it outside and released it, and it flew into the woods and disappeared.")

Northern flicker—Jonathan Franzen ("Right after my mother died, I spent a lot of time looking at a northern flicker that was hanging around my brother's house in Seattle. Objectively it's a stunning bird, and it had so much personality. That was when I first started having a glimmer of why one might spend time doing nothing but watching a bird.")

Black-and-white warbler—Starr Saphir (A bird she spotted when she was six, when her grandfather's car broke down in upstate New York. "I knew what it was because my grandmother had a copy of the old Audubon prints. You see these things in books and you don't think they actually exist.")

I began to think about "spark books." It occurred to me that most ardent readers would be able to pinpoint the book that ignited their love of reading. I polled a few friends to find out. Without exception, they all named a story from childhood.

SPARK BOOKS

Danny, the Champion of the World—the musician
Alice in Wonderland—Michael
The Wump World—Hiromi
Lafcadio: The Lion Who Shot Back—Terence
Harriet the Spy—Jim and Kelsey
Search for a Living Fossil—David

Watership Down—Kelly
A Light in the Attic—Julie
The Secret Garden—Martha
Bartholomew and the Oobleck—Stephen
The Lion, the Witch and the Wardrobe—Nobu

The spark of children's literature—stories lusciously rendered in words and pictures—was distinctive and determining. These books had a radiant quality, a quality that Anne Carson describes in her book *Decreation*. "When I think of books read in childhood," she writes, "they come to my mind's eye in violent foreshortening and framed by a precarious darkness, but at the same time they glow somehow with an almost supernatural intensity of life that no adult book could ever effect."

While I went on my reading binge, while the musician recovered, the air outside filled with migrant birdsong. I sat in my garden every day with my Peterson's *Field Guide* and a pair of binoculars trying to compare the living birds around me with the book birds on my lap. One day I emailed the musician and told him what I saw.

I wrote: "Based on its stocky red and grey body, I think it's a crossbill."

And he wrote back: "It's definitely not a crossbill. Wrong time of year. Probably a house finch (lots of

them around right now) and remotely possibly a purple finch (though I doubt this)."

It was a house finch. Any momentary feelings of stupidity and shame on my part were dispelled by the bird's charm. I watched for a long time, fell in love with its rosy-red crown and breast and its gregarious twittering. I felt the lift of bird in me, which felt like the lift of wine, or the lift of an ascending elevator, or the lift of discovering that I did not prefer the book to the reality. I wondered if this would be my spark bird.

Around this time, I completed writing a children's book about the ocean. It was the story of one child's encounter and connection with a magical place in nature. It was inspired by a family trip we had taken to British Columbia. We stayed with our friends in a beautiful hamlet on the Sunshine Coast. We looked out on a soft and ancient coastline and, in the far-off distance, a little island. One day as we sat on rocks watching a pod of dolphins magically leap across the bay, my younger son declared that he wanted to live by the "Specific Ocean" forever. This lovely malapropism set me thinking about the idea of place and where we find our specific oases of serenity and belonging. I couldn't stop wondering what it would be like to have a fixed point, the way Thoreau had his Walden, Willa Cather had Nebraska, Annie Dillard had Tinker Creek, Rachel Carson had Silver Spring. I had always

felt an allegiance to the migratory and rootless: to those of no place and many places, who (out of necessity) had developed the ability to move and adapt quickly. My friends were mostly of the diaspora, mongrel and scattered people. But seeing my younger son respond so forcefully to the ocean made me wonder what we were missing.

I began to wonder if one of the things we were missing was the opportunity to miss, to yearn for, to possess the sort of deep local knowledge that inspires you to fight for a place. Viewing nature as optional—as always elsewhere or in the past—denies us, or spares us, the work of caring.

The book I ended up writing, *The Specific Ocean*, is about the places that sustain us. It is about the joy and mournfulness of deep emotional connection. Mournfulness because when you love a specific place you open yourself up to the singular sadness that arises when that place is harmed or lost to you.

My close friend was deep in the throes of a book on climate change. She later wrote of hearing "the great farmer-poet Wendell Berry deliver a lecture on how we each have a duty to love our 'homeplace' more than any other." When the talk was over, she approached him for guidance. "I asked him if he had any advice for rootless people like me and my friends, who live in our computers and always seem to be shopping for a

home. 'Stop somewhere,' he replied. 'And begin the thousand-year-long process of knowing that place.'"

🐦

The musician was still recovering, so I decided to take my sons birding. It was the third week of April. I packed snacks, and we headed off to Ashbridges Bay in the east end of Toronto. It was chilly but sunny. My younger son started complaining the instant we arrived. He was too cold and too hungry and too itchy and his binoculars were too blurry. He finished all his snacks within five minutes of leaving the parking lot. In the park, there wasn't much to see. I pointed to a red-winged blackbird and we watched a few robins scurry-stop-scurry across the grass. I was determined to find other birds but I couldn't.

My younger son eventually pulled us towards the bay, where he had spotted a float of small diving ducks. There were three pairs, and we sat and watched them synchronize their dives, disappearing and reappearing in the viscous green water.

An hour passed, and I realized it wasn't the birds that had bored and annoyed my younger son, it was my attitude of leading and instructing.

I discovered my sons didn't need a guide or scout leader. All they needed was for me to lead them to beauty's general habitat, to wave my arm and say, "I think there might be something that way."

The musician's doctor said it was okay for him to walk. His knee would heal through gentle activity. So we made a plan to take a forty-five-minute trip to a marsh just outside the city. The Bonaparte's gulls were in full breeding plumage—a striking sight with their pale, dainty bodies and jet-black heads.

Things did not go according to plan. Our car started to fail ten minutes after we set out. We fish-tailed onto the shoulder of the highway as smoke plumed from the hood. The mechanic's verdict: overfilled oil tank, a leak, and (most seriously) a broken ball joint. The last was probably what caused us to veer off the road, and we were lucky the tire didn't fall off and the engine didn't blow. We were lucky we were not dead.

I felt shaken, so the musician suggested we go for a long walk to settle our nerves. We still had an entire afternoon ahead of us. There were still birds to see. The walking made us feel better. We walked to a diner for lunch. Then we walked a few loops around High Park, where we saw fancy wood ducks, a cigar-shaped chimney swift, a kingfisher, a great egret, a black-crowned night heron, and a solitary male gadwall that stayed still long enough for me to fixate on its delicate herringbone feather pattern.

I looked at the musician with new admiration. I had now learned that a person could be good at big stresses even if he was not so good with the normal little ones. I was happy to be walking with such a person, a person much like my father. If a crisis came our way, I knew he would act with rare decisiveness.

It began to rain. We crouched in the grass and the musician taught me to tell the difference between a male song sparrow (streaky red-brown breast with black dot at the centre), a house sparrow (fuller, black-bibbed, grey-headed), and a white-throated sparrow (striped crown, yellow brow). I learned that when it rains, the birds come down from the sky, and that when it rains and you realize you're alive, the rain goes from feeling bleak to feeling refreshing.

After we parted company, the musician stayed in the park and found three chipping sparrows—the tiniest sparrows. He wrote me later: "They were sweet and hoppy and I wanted to be close to them and I wanted them to feel safe and I said 'what a day we had today, you only live once, your knee can take it' and so I lay down flat on the wet ground and sure enough the little sweethearts got in nice and close to me and it was a delightful time."

I stayed up that night reading in bed, crawled back into my nest of books, feeling the residue of what hadn't been walked off yet. The reading was comforting

and cleansing. I had made peace with my reading. The true arts of survival lie in multiple realms, both physical and subtle.

The book world and the real world were not antithetical. Knowledge was not the opposite of passion. Good knowledge didn't smother ignorance's sparks of enthusiasm. Good books were not a mortuary of joy. The scientific words you learned to speak with more and more confidence and dexterity, the ones you began to make your own: these could be passion's *conduit*. There is a wilderness at the edge of all knowledge.

Die knowing something. Die knowing your knowing will be incomplete.

May

FALTERING

{
HOUSE FINCHES,
a MAGNOLIA WARBLER,
DUNLINS,
and WHIMBRELS
}

On the frailties of birds and humans,
especially when the terrain of our lives
is unstable.

In May, I discovered

hat my younger son was eating books. He licked their covers and ripped off pieces and ate them. This new habit was revealed to me one night when, complaining of nausea, he vomited up a piece of blue paper—a page from *The Complete Peanuts 1963–1964*. When I laid down a rule against eating books, he immediately complied and went back to reading them instead.

Had this book-eating behaviour come from nowhere, I might have been more alarmed, but at the time my eight-year-old son was a fretful boy—thumb-sucker, occasional insomniac, prone to stomach aches—with more than average nervous energy. Sometimes he expended this energy lavishly (making comics, dancing) and sometimes he expended it strangely.

During one memorably strange period, feeling himself under new social pressure at school, he would come home and fling himself around the house, as if tossed by gale-force winds, declaring himself— definitively—*fed up.*

I learned not to take these phases too seriously or too personally, though I did feel somewhat genetically responsible. I am an anxious person, easily pulled by currents of panic and worry. I come from a family of anxious people. Nail-biters, teeth-grinders, paper-rippers . . . I suspect there might have been some book-eaters among my ancestors in their thatched-roof cottages and drafty minka farmhouses.

I understood that my son needed to find ways to release the frustrations that had been building since he started grade school. I learned to breathe deeply when he passed through moods like a loose radio dial. Gleeful, aggravated, stormy, sensitive, obstinate, operatic. I nicknamed him Scramble, hinting at the impact his shifting tempers had on my state of mind.

In May, on the first semi-warm day of a spring that had been long in arriving, my younger son and I sat together on the bench in our front garden watching the house finches. Our usually quiet street was alive with pedestrians—women talking into cellphones, cloth bags on their arms, stroller walkers veering around an abandoned mattress, a couple carrying beat-up books and old vinyl from a lawn sale up the road.

The house finches sat high on our cherry tree, adorning the branches, singing their long, twittering songs. We were discussing my son's ambivalence about his new bicycle, specifically his anticipation of falling, and I was trying to say that while I understood his worries, it was hard for me to see him fear something

that was supposed to bring him pleasure.

As we sat there, the house finches began to descend, springing lightly from branch to branch, until they collected at the seed feeder hanging a few feet from us. The pounding of their tiny hearts, the nervous flurry of hunger and joy as they cast their caution aside, was palpable. My son, hypnotized, inched forward on his seat to meet the birds.

In May, I had not yet read Julian Barnes's *Levels of Life*, but I would do so in October and be reminded of my son's fear of falling.

> We live on the flat, on the level, and yet—and so—we aspire. Groundlings, we can sometimes reach as far as the gods. Some soar with art, others with religion; most with love. But when we soar, we can also crash. There are few soft landings. . . . Every love story is a potential grief story.

When I read this, I thought, Yes, this is it, the crux of our problem. In Barnes's spare and beautiful meditation on life's inevitable crests and troughs, on the things that literally and emotionally uplift us (hot-air balloons, love) and the things that plunge us to earth (the death of a loved one), I found a distillation of my son's existential chagrin. "Every love story is a potential grief story."

All striving may lead to suffering. What goes up must come down, what begins must end. My son's (and, arguably, my own) hesitancy in the world was a product

127

of extensive foresight mixed with a pessimistic disposition, a perfectionist quality mixed with a sense of inadequacy. This is why we did not have freer souls.

My son had already mapped out what would happen once he sat on that bicycle seat, and he was tempted to protect himself from the pain and indignity of that experience, even if it meant missing out on some fun. *And yet*, he was also a boy who had recently fallen twice, unaccountably, while simply standing on the ground ("on the flat, on the level"), which forced him to consider whether one could ever really be in control.

Barnes: "If being on the level didn't shield you from pain, maybe it was better to be up in the clouds."

What use was having a cautious soul if accidents and rogue elements could still throw him off his feet? What if there was no safe path in life? What if the pain of not doing something was greater than the pain of doing it?

It was a quandary about bicycles and life.

In May, my younger son was laying down tracks, deciding what sort of boy to be.

The neighbourhood that spring crackled with daring: cyclists riding with no hands, children playing ferociously in the barren field near our house. One boy took a running leap into an aerial somersault. On seeing this, my husband grimaced and turned away. In sports such as football and boxing, a little sweaty stumbling is expected—and even welcomed. Then there are sports where the aim is perfection. My

husband cannot tolerate the latter. He does not like to watch the Olympics. Not at all. The mere sight of a gymnast at a vault, a diver on a ten-metre platform, or a figure skater preparing to do a triple Axel is enough to make him leave the room.

"How can you stand it?" he asks.

It pains him to see a person suffer disappointment or invite potential injury, and he can't stand the sight of a crowd waiting for a mistake to transpire. For similar reasons, it unsettles him to hear or watch an opera singer falter. Opera is an art of precision, of faultless and divine voices. As much as he loves Maria Callas, at moments her wobble is simply too much for him, she seems too dangerously out of control.

The American video artist Bill Viola once spoke of "falling" or faltering as the optimal state for making art. John Baldessari said, "Art comes out of failure." Some artists take pride in striving where they risk failure. Samuel Beckett: "Ever tried. Ever failed. No matter. Try again. Fail again. Fail better." Dutch conceptual artist Bas Jan Ader: "All is falling."

Ader was a maestro of falling. He filmed himself falling off the roof of his house, falling into a canal, falling off a tree. He captured the failure of losing his footing, of being incapable, of facing gravity, of the misguided endeavour. In a particularly poignant work, he took photographs of himself in front of a pine forest, standing and then lying face down, felled, with a number of trees also felled around him.

In May, one night, while thinking about falling I came across a funny and melancholy dance by Pina Bausch on YouTube. Early into the performance ("1980—A Piece by Pina Bausch"), a woman begins to skip around the stage in a large circle, waving a white handkerchief. "I am tir-ed, I am tir-ed," she chants in a lilting rhythm while Brahms's Lullaby plays in the background. Round and round she continues as real exhaustion catches up with her. Her chant grows halting, her steps clumsy. Her arm quakes with the effort of holding the handkerchief in the air.

Bausch created this work soon after her long-time companion and closest collaborator, Rolf Borzik, died of leukemia.

Sometimes we falter not because the ground beneath our feet is unstable but because it's exhausting to keep moving, to keep trying, to keep performing the same actions again and again.

Strong one moment, vulnerable the next, we falter because we are alive, and with any luck we recover.

Once I witnessed a windstorm so severe two 100-year-old trees were uprooted on the spot. The next day, walking among the wreckage, I found the friable nests of birds, completely intact and unharmed on the ground. That the featherweight survive the massive, that this reversal of fortune takes place among us—that is what haunts me. I don't know what it means.

MARY RUEFLE,

from *Madness, Rack, and Honey: Collected Lectures*

In May, waves of migrant birds were passing through the city's ravines, parks, and backyards. One morning after breakfast my sons and I saw a delicate magnolia warbler in our lilac tree. We huddled by the balcony door and watched the tiny bird with its black-streaked yellow breast. I imagined it weighed as much as a Sharpie.

That bird had likely come from Central America, resting and refuelling in Toronto on the way to its breeding grounds in northern Canada. It might have flown for sixty hours without stopping. I pictured it flapping its short wings and chirping, "I am tir-ed, I am tir-ed" and all the other songbirds—the fifty million songbirds said to travel through Toronto during spring migration—all chiming in: "I am tir-ed, I am tir-ed." We can learn something from the scrappiness of birds that come from as far away as the Argentine pampas and the Amazon jungle, from vanishing southern forest homes to equally threatened northern forests. I want to know how to be as undaunted as a migrating bird, how to sustain that perennial fortitude.

Night after night, an invisible songbird stream passed through the darkness. The birds came so close at times that we could hear their calls through open windows.

A few days after seeing the magnolia warbler, I accompanied my father to a late-night MRI, a checkup to monitor his cerebral aneurysm. It was his first time back at the hospital since his prior escape. A brief visit, I promised. His balance was still off, a slight hesitancy shadowed his movements, but he was a bit steadier. I

sat in the quiet waiting room during the hour-long procedure. A large, wall-mounted television played the news. Chris Hadfield, the first Canadian to command the International Space Station, had just touched down after nearly five months in orbit. Three parachutes slowed the spacecraft before it landed softly on the flat steppes of south-central Kazakhstan.

I heard my name so I looked around and saw my eighty-four-year-old father making his way towards me like a man on a listing ship deck. They'd finished the MRI. His face was pale grey. He said he felt a stabbing pain behind his left knee. I could see in his eyes that the pain was very bad. I took him down two floors to Emergency. "We're here anyway," I said with false calm.

A nurse took us into triage. My father, white-haired and delicate, Roman-nosed, was seated in a reclining chair under another TV monitor. On it, Chris Hadfield, with his receding hairline and trademark moustache, was also seated in a reclining chair. Hadfield was getting a preliminary medical checkup while he readapted to gravity. I watched the doctor cuff my dad's arm while a doctor on TV cuffed Hadfield's arm.

My father's reflexes were poor, but the pulse in his foot was strong. The pain had started to subside. His face was no longer graven with suffering. The doctor reassured us my father would be fine.

"What about the dizziness?" I asked.

"It may get better with time," the doctor said, looking away. My father took this to mean he was

recovering at an infinitesimal rate, a faint promise of rebound.

As I helped my father to his feet, I felt the true depths of his faltering. I felt the faltering of his body, I felt the faltering of his independence and dignity. He trembled with the instability that came from losing steadying work, the existential shakiness of no longer being in the chase, no longer on the swiftly turning wheel.

A way of knowing that you have definitively crossed the line into serious old age, writes Jenny Diski, is that your otherwise compassionate doctor tells you there is nothing to be done, that "'you'll have to learn to live with it.' . . . You see a virtual shrug that says you are no longer young enough for a resource-strapped institution to be overly concerned with getting you back to full health. There are higher priorities, and they are higher because the patients are younger."

Constant dizziness? Shrug. Nerve pain? Shrug. Chronic leg numbness? Shrug. There was nothing to be done. Nothing worth doing. With the sadness of watching a magician take a bow before he has performed the very trick you came to see, we watched the doctor leave. We had exited the land of presto cures and illusions of recovery.

We walked tentatively to the parking lot. As we approached the road we needed to cross to reach our car, my father—a former war reporter who had once roamed the world, walked through craters, along jungle trails, up mountains—paused to consider the opposite curb.

The night streets were quiet and peaceful. We drove past a few joggers and some university students smoking outside a pub. We stopped to pick up milk and bread, grounding ourselves in familiar actions. I sensed from my father that he didn't want me to take him home yet, so we sat in the car savouring the simple relief of being together.

Chris Hadfield, reflecting on his mission, said, "Who'd have thought that five months away from the planet would make you feel closer to people?"

I'd accompanied my father on so many emergency-room visits, at least five times when he was at the edge of dying, and every time we left the hospital it was like landing again.

As we sat there in the car, I thought back to taking my father to see a doctor about cataract surgery the year before. The appointment had been in an ancient medical building, and when I returned to pick him up, I opted to take the stairs two at a time instead of waiting for the slow, juddery elevator. As it turned out, the stairs took three times as long because halfway up the narrow staircase I got stuck behind an elderly Greek couple. Very concerned for each other, they held hands as they slowly made their way up the stairs in their gleaming black Reeboks. It touched me to see them helping each other in their matching shoes, but that wasn't the most moving part. What really got to me was that they laughed the whole way to the top. Every painstaking footfall cracked them up. They

grunted and guffawed, until I was laughing too. We laughed as if aging was the biggest prank in the world.

Late one night that May I heard a mournful cooing in the tree outside my bedroom, followed by a sharp whistling of wings. As the mourning dove departed, I tried to listen for the flight sounds of other birds that might be passing overhead, using their calls to stay connected and on course in the darkness.

I had read somewhere that up to 50 percent of migrating birds die on their journey. They encounter extreme weather, predators, or human-borne obstacles. They leave the South using the earth's magnetic field to navigate and get swept off their migratory flyways. They cross over large bodies of water or vast expanses of arid land and plummet exhausted after fighting strong headwinds and storms. Migrating requires an immense expenditure of energy. Migrants can lose one-fourth to one-half of their body weight during the passage from south to north.

Those that manage the main crossing enter cities full of peril. They expend valuable energy and time trying to navigate mazes of high-rise towers and often don't have the strength to continue—colliding with windows and reflective buildings, bedazzled by bright lights they mistake for constellations.

In Toronto, as in other cities, volunteers scour the ground of the financial district in the pre-dawn darkness each day. They carry paper bags and butterfly nets to rescue injured birds from the looming stam-

pede of pedestrian feet or, more frequently, to pick up the bodies.

The volunteers are part of a group called the Fatal Light Awareness Program, or FLAP, which works with building owners to reduce the threat that glass and light pose to migrating birds. That spring I had taken my sons to see their annual one-day display at the Royal Ontario Museum. For several hours, the corpses of thousands of birds killed while travelling Toronto's skies were laid out on the floor of the rotunda. Small birds and large birds—ninety-one different species—were artfully arranged in a sad but beautiful mandala. I pictured them flying into glass, knocking themselves out, dropping like stones to the pavement.

The museum teemed with children on March break, and the temporary FLAP display spoke for itself. The group had provided no explanatory text, gave no speeches. Our only help interpreting the display came from two children volunteers standing behind a rope cordon. One of them, a solemn nine-year-old boy with latex gloves on his hands, approached us with a Cooper's hawk. He allowed us to pass the lanky bird carefully between us. It was soft and cold. Its heaviness surprised me, but then I remembered this was a bird that could devour a pigeon. The boy went away and returned with a weightless kinglet, creating a tiny hole in the pattern. We asked to hold a magnolia warbler, but the boy shook his head and said, "No, that's enough for today."

The boy gently returned the kinglet to its spot, then walked back to his post. There was a faint smell of

thawing cadavers. In a little more than an hour, FLAP would dismantle the display. The birds would be collected and sorted into clear plastic specimen bags.

In May, the musician invited me to the annual Whimbrel Watch at Colonel Samuel Smith Park, in Mimico. The whimbrels with their long, curved bills and tapered wings come from coastal Brazil, and every year between May 22 and 29, following ancient instincts, they fly over the west-end park on their way to feed and breed in northern Canada. It is considered one of the most impressive migrations in the bird world. Since 2009, a volunteer citizen-science effort has mapped the movements and staging patterns of the large and leggy shorebirds, which have undergone a 50 percent decline over the past twenty years.

When we arrived, a dozen whimbrel counters were already gathered on a scrubby hill by the lake. Among those who had been sitting, waiting, watching since dawn were a retired school principal with a long-lensed camera, a former Sears catalogue photographer with an HD spotting scope, and a couple with matching $2,500 Swarovski binoculars.

The counters had received news that 751 whimbrels had left their wintering grounds in the coastal marshes of Virginia the night before.

As we huddled together on our windy moor, the air released a waft of catnip. The sun dipped low on the horizon, casting the world in a sweet rusty-orange light, which gave the rocks an amber glow. The air

filled with gnats as the wind and dusk settled.

We looked up, up, up again. Then we looked down at ten black-billed dunlins wading off the rocks. The little black-streaked, red-brown birds followed the tideline, retreating when the waves arrived and rushing forward as they receded. I sketched while the musician took photographs. Every now and then the dunlins would startle and swoop in spirals over the water. I loved the way they bent back for the stragglers, moving tight and flexing, then coming apart and spreading wide.

Suddenly a voice cried out from behind: "Here they come!" We hurried back to our post as the air filled with a choppy whistling sound. I saw a wavering blur transform into a fast dark cloud as a shoal of whimbrels passed right over our heads. The way their tapered wings pumped without rest showed such earnest effort. They were so close I couldn't take them all in. But I felt the chorus of wingbeats in my chest.

A few minutes later, a friendly bearded man named Albert announced the final count: 215—a healthy tally and yet, given what I now knew about the improbability of flying halfway around the world and making it safely, I couldn't help but wonder in the blue-tinged twilight about the other 536.

The National Audubon Society list of the top twenty common birds in decline in the United States since 1967:

1. Northern bobwhite
2. Evening grosbeak
3. Northern pintail
4. Greater scaup
5. Boreal chickadee
6. Eastern meadowlark
7. Common tern
8. Loggerhead shrike
9. Field sparrow
10. Grasshopper sparrow
11. Snow bunting
12. Black-throated sparrow
13. Lark sparrow
14. Common grackle
15. American bittern
16. Rufous hummingbird
17. Whip-poor-will
18. Horned lark
19. Little blue heron
20. Ruffed grouse

In May, I heard many birders remark that we were seeing the worst spring migration in thirty years. The numbers were notably low. We had sudden heat, then icy cold. Was this a normal fluctuation? Was it just a bad season? Was it a sign of something more sinister? No one knew.

Some declines are natural and inevitable. Some are not. There was a distinction to be made between the regular frailties of birds (their everyday expirations,

the losses that occur in the hurly-burly of migration) and the more catastrophic faltering brought on by a threatened ecosphere.

Deforestation, habitat loss, hunting, pesticide use, urbanization, predatory pets, and climate change . . . The decline of migratory birds is an indication that nature is out of balance. *Rising temperatures, earlier springs, melting ice sheets, rising sea levels, changing rainfall and drought patterns, worsening heat waves, extreme precipitation, acidifying oceans.* In ordinary times, the benefits of migration made it worthwhile for birds. But what about extraordinary times?

The term *shifting baselines* describes slow, almost imperceptible changes in an ecosystem. A fisheries biologist named Daniel Pauly first used the term in 1995 to explain how ecological standards could be lowered to such a degree that humans could tolerate things they once wouldn't have. In Pauly's opinion, the deterioration of wildlife has been enabled by collective forgetfulness. Our faulty memories and relatively short lifespans have made us unreliable witnesses. We are unable to truly grasp how much of the natural world has been altered and destroyed by our actions because the baseline shifts over time and generations have rendered us blind. Our standards have been lowered almost unnoticeably. What we might regard as pristine nature today is a shadow of what once existed. We can't seem to remember how things used to be.

By the same token, when I stood with the musician

on that hill in the Toronto village of Mimico watching
the flight lines of whimbrels against the dusk sky, I was
witnessing a vision that future generations might never
enjoy or even know to miss. The whimbrel is not now a
"species of concern," which means it is still fairly
plentiful, but I cannot predict how the baseline will
shift or what future generations will accept as the norm.

It isn't unthinkable that the whimbrels could
disappear, because the unthinkable already happened
116 years ago when the passenger pigeon—another
species once considered robust—vanished from the
skies of Mimico.

The passenger pigeon lived in vast migratory flocks
until the early twentieth century, when over-hunting
and habitat loss led to its extinction. In Toronto, the
birds used to congregate on the banks of Mimico
Creek before making the flight across the lake. (The
name Mimico is derived from the Mississauga word
omiimiikaa, meaning "gathering place of the wild
pigeons" or "place abundant with wild pigeons.")

In the 1860s, so the story goes, the birds were so
plentiful (a flock numbering in the millions took
fourteen hours to pass over nearby Niagara-on-the-
Lake) that a dozen birds could be felled with one shot.
But fifty years later, the birds were gone.

In 1900, five passenger pigeons were spotted flying
over Toronto Island. The world's last passenger pi-
geon—a captive named Martha—died on September 1,
1914, at the Cincinnati Zoo.

The news led to ghost bird sightings and fierce

denials. How could it be? How could a species that existed in such prodigious numbers just vanish? How could the robust become so vulnerable?

The story of any lost life form is a tragedy, but the disappearance of the passenger pigeon occurred on a scale unmatched in human history. The cautionary tale serves as a crash course in impermanence, a reminder that nature is finite.

What other things vanished from the world in 1914?

What entered the world? The traffic cone, the Panama Canal, safety glass, the world wars.

Some losses are irrevocable. Or are they? As I write this, scientists working with a U.S. non-profit called Revive & Restore are trying to resurrect the species. Through a process called de-extinction, involving DNA from museum specimens, a band-tailed pigeon embryo could be converted into a passenger pigeon embryo. De-extinction advocates say species revival offers humanity a chance for redemption. By re-creating species we drove to extinction, we have a chance to right a historic wrong. The skies could fill once again with passenger pigeons—an immortal horizon against which our loss, and the admonitory truth that loss offers the world, would be cancelled.

The history of humans is a history of disregarding nature's wake-up calls. We deny and bargain. We adjust the baseline. We reset our memories. We practise genetic wizardry and mad science. We modify our bodies and tamper with the land. We deny death and decay. We override limits, compensate for our vulnerability

with engineering and know-how. We ignore the feed-back and messages our bodies and the earth deliver.

While there is a place in my heart for a resurrected passenger pigeon or an approximate facsimile, I am wary of a world with no limits, a world in which humans feel omnipotent, in which appeals to change course are drowned out by the euphoria and hubris of invention.

Can we remember our vulnerability when we feel strong again? Can we feel both the frailty and capacity of our bodies, the sorrow that continues inside joy? Those of us who have experienced extreme events (whether an accident or an illness or the death of a loved one) are often surprised to discover how quickly ordinary life resumes, how forcefully the world sweeps in to reclaim us, as if nothing special had happened.

I do not want to be a wizened old woman reminisc-ing to my grandchildren about whimbrels that once passed through the skies.

Sometimes it is worth acknowledging the places and moments where things break down, where life is at its limits. Sometimes we stay with the faltering because it is a fragile embodied world, made all the more so by our efforts to suppress this awareness in the name of technological growth and progress. There is no life without adversity, failure, and frailty. Sometimes an eight-year-old boy's worries and discomforts cannot be easily resolved. Sometimes illness does not proceed to full recovery.

At the end of May, when fewer birds migrated through the night sky, my younger son awoke from a dream and climbed into our bed, exhausted and exhilarated. He had dreamt he was on a giant tree swing, rising higher and higher, past his waking terror of heights.

"It felt like flying," he said, pointing to the phantom soaring feeling in his chest.

"Did you fall?" I asked.

"No."

"Did you jump?"

"No," he said, hesitating for a moment. "But next time I think I will."

I couldn't tell if he really meant this, if he felt brave or he thought I might wish for a braver son. It didn't really matter. It was a good dream.

Later I will tell him: our courage comes out in different ways. We are brave in our bold dreams but also in our hesitations. We are brave in our willingness to carry on even as our pounding hearts say, You will fail and land on your face. Brave in our terrific tolerance for making a hundred mistakes. Day after day. We are brave in our persistence.

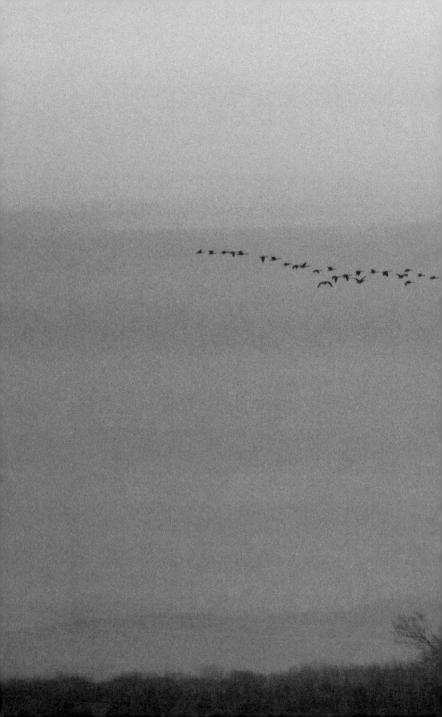

SUMMER

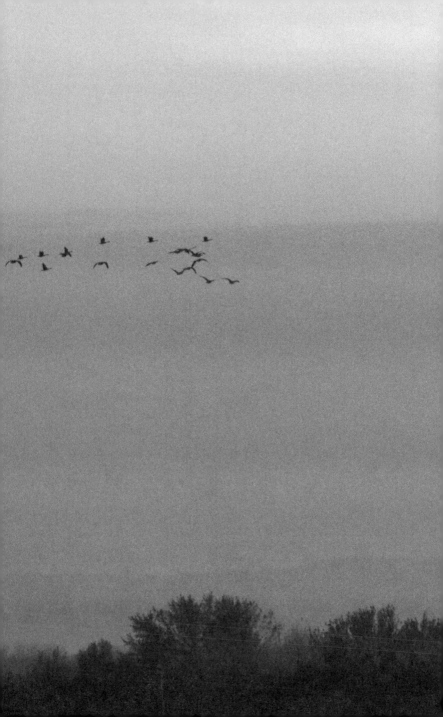

June–July

LULLS

{
a GOLDFINCH *and*
RED-NECKED GREBES
}

On peaceful lulls and terrifying lulls
and the general difficulty of
being alone and unbusy.

The sky was a pre-storm

mauve, the water an oxidized green, and we sat on a public walkway about six feet away from a floating nest. We were at Humber Bay Park, where a pair of red-necked grebes with black breeding caps had nested and recently hatched three chicks. The female grebe sat regally on her untidy throne while her zebra-striped babies nestled on her back. The male trolled the pond for minnows, plunging and surfacing, three tiny beaks chewing the air whenever he returned with food for his family. Both parents took turns on the nest, incubating the remaining egg, going for short swims with the hatchlings.

The nest was a solid but messy mound built of twigs, reeds, and water plants, but also a plastic shopping bag and an old ice cream container. Like most modern homes, it was a work in progress. Every now and then the female grebe delivered a few new weedy bits to her mate, which he arranged according to some sloppy vision of home betterment.

The photographers lining the walkway with us eyed the clouds anxiously. A feeling of restlessness spread through the group. The musician was moving about, angling his camera this way and that, with the buoyant intensity of somebody who had just consumed a lot of sugar.

Then with the rumble of thunder in the distance, it was time to run. We ran out of the park, stopping for a moment to see a Baltimore oriole's nest and a gold-finch perched on a branch a few feet away. Tantalizingly photogenic, it glowed a supernatural yellow against the stormy charcoal-blue sky. I could see the musician hesitate, hand on his camera bag.

With a final dash we made it to shelter as the sky burst open.

Another grebe had hatched by the time I returned the next day, sons in tow. We watched the babies goof around like slapstick artists, falling over, scrambling onto their mother's back.

That night my sons embarked on some grebe research. The younger recited a few basic facts—*aquatic bird, expert diver, elaborate courtship display, loud mating call*— and then he paused. "Oh. This is epic," he said. "It says here the fossil record shows that grebes were around when dinosaurs roamed the earth!"

In the quiet that followed, I believe each of us imagined some version of a grebe and triceratops meet-and-greet. My own mental picture was lush with megafauna and boggy with ancient marshlands. In that instant, all modern infrastructure evaporated and I had a glimpse of what J. B. MacKinnon in his enchanting book *The Once and Future World* calls the "understory"— an inkling of the "place that lived before the living city."

My sons' imagined scenes were probably more ferocious, less placid, but I think we all agreed that our klutzy hatchling friends suddenly seemed more impressive. The grebes connected us to an ecological history that was seventy million years old. They had journeyed through time and thrived, gorgeous orphans from long-expired worlds. I thought, What could be more invincible than a grebe?

But sometimes thoughts change with the rain. In this case it wasn't any old rain. It was record-breaking rain, the rain of a warming planet. On July 8, 2012, in Toronto, 126 millimetres of rain fell in less than two hours. (To compare: the average rainfall for the entire month of July in Toronto is only 74 millimetres. The previous record for rainfall was set at 121.4 millimetres in 1954.) The rain came down with the force of crashing waves. It caused flash floods that set cars afloat, stranded rail commuters, and knocked out power to thousands.

"It is really probably the most intense, wettest moment in Toronto's history," a senior climatologist with Environment Canada told the Canadian Press. "No infrastructure could handle this . . . You just have to accept the fact that you're going to be flooded."

I watched and listened to the storm from my bedroom: the lashing of tree branches against the window, the whoosh and howl of wind, the abrupt wail of sirens rushing to a west-end fire.

I worried for the grebes. No longer convinced of their invincibility and prehistoric sturdiness, I wrote to the musician to see how he thought they were doing. He replied: "I think they just nestle in and take it. They're quite hardy in that way. They may have gone over and hid in the reeds too, who knows?"

The next day the roads and sidewalks had a different, slicker texture. The local dog park, located near a ravine, was a lake. A giant sinkhole had appeared on my friend's street.

I wanted to go check on the grebes, but the days were suddenly over-full. My husband and I seethed with stress and ire. Finally, after a stupid fight, we packed ourselves into the car and headed for the grebes.

The early-evening sky was still a bold blue. The musician was there on the walkway with a ragtag group of about ten others. The shallow water of the inner bay was about six feet higher than normal, but the nest—sodden and atilt—was still strong enough to hold a family. I felt relief, then besotted with happiness, as I watched the chicks swim around on their own.

It was a relief to be back with the bird-loving weirdos, soaking up their stand-and-stare vibe, basking in the still night air that carried not even a breath of wind. In this decelerated outpost, twenty minutes from our house, everything my husband and I had been arguing about was forgotten. Nothing to prove, nothing to lose, nothing to do. Here, away from the scaffolding and schedules and the extreme depletion of stress, was the understory of life.

As night fell, as we stood together at the edge of a city named after the Mohawk word *tkaronto* meaning

"where there are trees standing in the water," I tried to picture the area covered in aspen and poplar forests. Then I went back further and pictured the former shoreline as it would have existed 12,500 years ago, well to the north of where we now stood. I pictured us submerged in glacial lake water.

Two weeks later, high summer: my sons and I visited the grebes again. To our surprise, they were now ungainly teenagers with dirty puffball bodies. Their infancy had sped away. They still had strange zebra markings on their heads but they were now, unbelievably, almost full size. As a mother of a twelve-year-old, I recognized this mishmash of little-bird-big-bird. The nest, bedraggled and seeming to be sinking at a tilt, was familiar too.

Enamoured of the gawky grebes, I did not notice things had become slower on the bird front. It was the musician who informed me. "We have entered the great lull of summer," he said. With the end of spring migration came the onset of a quieter season as visiting species moved north for breeding. We had reached the centre of our time together, an intermission.

I came home from my last trip to see the grebes and thought, What most of us do with a lull is try to fill it, with stuff, with recognizable busyness.

As I thought this, I spent hours online. I read articles about efforts to weather-proof cities from climate disaster and I downloaded African mbira music because a friend had told me it was good music to write to and I watched *Searching for Sugar Man* on the musician's recommendation.

I told myself I was researching and good research was promiscuous. Subjects came and went. I read about John James Audubon and browsed Grace Paley and post-Pinochet Chilean writers and purchased a necklace for a friend on Etsy. Then there was the vintage Pleats Please scarf for my mother and the Mizuiro-Ind shift dress for me. I watched comedian Louis CK's famous "Everything's Amazing and Nobody's Happy" rant against cellphones and incessant connectivity: "You need to build an ability to just be yourself and not be doing something. That's what the phones are taking away, is the ability to just sit there. That's being a person. Because underneath everything in your life there is that thing, that empty—forever empty."

Because my "research" was vigorous but useless, I was left with nothing at the end of the day. I thought I was defying the void when really I was just changing its outward appearance.

For as long as I can remember, I have asked myself, How do you find peace with inactivity? I have yet to come up with a satisfying answer, though I have pursued the answer in various predictable ways: bad relationships, mindless consumerism, travel, yoga, excessive exercise, psychotherapy, home juicing, binge TV watching, knitting, festive eating, even through creative practice. I have come to realize that a lull is not just an occupational problem. It is an emotional, intellectual, and existential one as well. If I ever find an answer, I figure I will feel less fatalistic about intervals, periods of unemployment or dormancy, fallow times. I might be easier on myself and engage in less-anxious behaviour. I might achieve the kind of Zen serenity that allows one to sit with unresolved and sometimes aching emptiness, to feel the silence and immensity of the universe without being too rattled by it.

Eve Sedgwick, in therapy for depression after cancer treatment, has a moment of realization: "I've figured out what it means when I complain to you about things," she tells her therapist. "Or to anybody. When I tell you how bad it is, how hard I've worked at some-

thing, how much I've been through, there is only one phrase I want to hear. Which is: 'That's enough. You can stop now.'"

Sitting now at my desk, I watch my cat, luxuriating on the floor in a rectangle of sunlight. She is happily watching nothing because there is nothing to watch. She does not appear worried about a dearth of events or the lack of a narrative dialectic. She does not seem to fear that if she stops moving the walls will collapse, that she will end up in bed and never again rouse herself to stand.

EILEEN MYLES: In some weird way, the spaces between the work are what's really interesting.
DANIEL DAY-LEWIS: Definitely. That part is obscured when you're young because your drive is always leading you from one place to another. It's the resting places or the periods of lying fallow where you do the real work.
(from *The Importance of Being Iceland*)

In mid-July I went on a daylong meditation retreat with a teacher known for doling out irreverent and charismatic advice. The teacher has attracted a loose following of creative types to his open-minded and joyful workshops. He eschews the role of the guru and runs something called the Consciousness Explorer's Club, which mingles spiritual practice with social justice activism and creative investigation.

The teacher had us practise breath meditation, or anapanasati. In this meditation the practice is mostly sitting and feeling your breathing. Eventually you stop shaping or manipulating your breath and you feel your body breathing on its own.

"Meditation will not extinguish all your busy thoughts," he said. "But eventually you may find that the gap between them gets longer. As the pressure in your body and mind decreases, you may begin to crave those lulls and that stillness."

At some point, a feeling of fatigued concentration overtook me and I remember lying down and falling asleep.

EILEEN MYLES: The thing that's scary about not doing anything, or not doing what people are inviting you to do, is you feel like you are facing death in a way.

DANIEL DAY-LEWIS: Yeah, I think you're right. It's a little death and you have lots of little practices.

A lull can be soothing, tranquilizing, and even restorative. It can be a time to retune and replenish. A lull can suggest a state of peaceful hovering, a prolonged mental daydream, a weightless interval. One can be lulled to sleep or lulled into a trance.

Yet for many artists I know, the word *lull* signifies the exact opposite: the absence, the flaw, the incompleteness, something lethal and dangerous, a source of fear and melancholia. There are layered reasons for this:

1. Superstition. A common and reasonable anxiety among artists is that creativity will flatline without constant practice. Confidence will wane, muscles will grow flaccid. What starts off as a lull will become a rut. The muse will flee.

2. *Capitalism.* We live in a culture of high performance and competitiveness. Even artists, perennial outlanders who appear to have more freedom from conventional market expectations than most, feel they must maximize productivity and extract the most out of every day. Even those who live outside the city, in the lulling countryside, feel time-pressured and the relentless demand to perform and stay connected. Even the notion of betterment, which seems benign, can be wielded as a baton of self-discipline.

3. Existential fear. We live in a culture where even the most banal and shallow gesture is considered better than no gesture. Many of us would rather engage in mindless functioning than face the prospect of being inactive. Being an artist is not only financially precarious but existentially wonky. Most writers will tell you they are writers only insofar as they are writing. When the writing stops, the trouble begins—self-recrimination, fears of disappearance, of irrelevance, of the loss of one's best self, et cetera. Describing the existential difficulty of settling into blankness, that taunting vacancy, writer Kate Zambreno notes: "I know I should leave the house when I am stuck, stalling, but I feel this clawing inside, like if I do not write well I do not deserve the day. I tend to slink into a slothlike demi-existence, watching things behind a screen."

4. Therapeutic habit. For those who find work makes them feel light and happy, wards off the doldrums, a lull can mean a setting in of heaviness and despair. In some cases, hard work is an alibi for escape—a means of shirking life and any mess that might be waiting for you once the busyness stops. "Working all the time," writes Karl Ove Knausgaard, "is also a way to simplify life, to parry its demands, especially the demand to be happy."

What many discover is that the need to do, accomplish, and succeed perpetually replenishes itself. My father regarded lulls not as a grace but rather as enemies. His

generational, class, and personal baggage was such that the only thing that mattered was Work (of the big-W variety, not the small-w work of cleaning up and tending to family life). Work was a form of mesmerism and ego refuge: best to keep going.

His extreme work ethic became my work ethic from an early age.

But the ethos of relentless, panicked production really came with motherhood. Once I had my first child, I discovered I could not check out when I wanted to. I did not have the licence writer Geoff Dyer describes of "letting life find its own rhythm, working when I felt like it, not working when I didn't." It became harder to exist easily, away from expectations.

Lately, when I am especially busy, I think of an artwork by my best friend entitled "Vigil." It is a reimagined scene using an old family photograph of a woman asleep on a lawn chair. The woman is isolated against a spinning landscape patterned with glowing orbs of light. It is not the sleep of someone sun-dozing. It is the Sleep of Oblivion. I happen to know that the woman pictured is my friend's mother. I also know that at the time the original photograph was taken, the mother in the picture had three young children and was studying for a graduate degree in occupational therapy, every minute accounted for.

There is something subversive about the sight of a woman who is always on call, always in a heightened state of watchfulness and awareness, momentarily checking out—zoning into her own internal infinity.

There is so much finitude in the lives of the mother (and father) artists I know. We are so often counting (time, money, errands, cups of coffee, hours until bedtime). We are too often irritable and impatient with our children, and this makes us uneasy and sometimes ashamed.

I want for every overextended person in my life stretches of unclaimed time and solitude away from the tyranny of the clock, vast space to get bored and lost, waking dreams that take us beyond the calculative surface of things.

By definition, one does not know whether a lull is interesting or uninteresting, fruitful or unfruitful, until it's over. And yet—it is hard not to pack the lull with hopes and dreams. In the Hollywood story of the artist genius, the luminous lull of childhood (with its shadows of loneliness and boredom) becomes the spur for creative exploration. The lull gives birth to glory.

But it is not glorious lulls that concern me. It is the lulls that have no velocity, that offer no structured reassurance, that bloom unbidden in the middle of nowhere—when the work is done, when children

leave, when illness comes, when the mind stalls. One does not ask of a lull: What can you do for me? These lulls do not have the quality of idyllic floatiness we associate with creative loafing, vacations, or leisure time. (If they did, we might fight them less readily and feel less personal distress.) These lulls carry a restive feeling, the throb of being simultaneously too full and too empty. They evoke what Jean Cocteau once described as "the discomfort of infinity."

What if we could imagine a lull as neither fatal nor glorious? What if a lull was just a lull?

When I left my meditation retreat, my mind felt momentarily rinsed. I found the busy street waiting outside our quiet room. I felt tired but peaceful. The hedges were chirping with invisible sparrows. The road streamed with cyclists in cheerful summer dresses and sunglasses. The green of the trees was dazzling in the late-afternoon light. As I walked home along side streets, BBQ smoke rose from backyards.

I was the furthest thing from a regular meditator but I liked the way meditation pointed me to an understory of quiet that existed beneath all my busyness and all my social roles. Meditators sometimes call this the "quiet feeling tone" of the body. The understory is that grebe place that withstands the onslaught of bad weather and

modernity. It may be hidden or veiled by static, but once we tap into it, it offers a glimpse of our non-doing selves and, possibly, a better version of a personal life.

Now when I hear birdsong, I feel an entry to that understory. When I am feeling too squeezed on the ground, exhausted by everything in my care, I look for a little sky. There are always birds flying back and forth, city birds flitting around our human edges, singing their songs.

If the wind is going the right way, some birds like to spread their wings and hang in the air, appearing not to move a bit. It is a subtle skill, to remain appreciably steady amid the forces of drift and gravity, to be neither rising nor falling.

August

ROAMING

{ PILEATED WOODPECKER }

On altering your course,
sliding between disciplines,
and leaving the door open
for the unknown.

As long as I

can remember I have been drawn to people who have side loves. Maybe because no single job or category has ever worked for me, I am particularly interested in artists who find inspiration alongside their creative practice. It could be a zest for car mechanics or iron welding (Bob Dylan) or for bee-keeping (Sylvia Plath). I love the idea that something completely unexpected can be a person's wellspring or dark inner cavern, that our artistic lives can be so powerfully shaped and lavishly cross-pollinated by what we do in our so-called spare time.

I told the musician that if I could time-travel, my dream would be to spend an afternoon butterfly catching with Vladimir Nabokov or gathering mush-rooms with John Cage. I would garden with Emily Dickinson and fly in a plane with Antoine de Saint-Exupéry (but maybe not over the Sahara). I can get very wistful about other people's intense interests.

"What drew me to you," I said to the musician, "was not the fact that you were a musical talent or a great

photographer or apparently very friendly. What drew me to you most was this quality of intentional roaming."

I said, "It was your fence-jumping knowledge. I know you're not a bird specialist, but you know more about birds than I know about any single living thing. You know more about birds than I know about babies, and I've had two of them!"

When I said all this the musician became slightly confused and embarrassed. But I could tell he was flattered to be compared to Nabokov.

Vladimir Nabokov's interest in the field of lepidopterology was first sparked by the books of Maria Sibylla Merian, which he found in the attic of his family's country home in Vyra, Russia. Having never learned to drive, he depended on his wife, Véra, to take him butterfly collecting. Though photographs make him look like a playful hobbyist with his floppy butterfly net and high-waisted shorts, he was in truth a serious taxonomist. During the 1940s, for example, he was responsible for organizing the butterfly collection of the Museum of Comparative Zoology at Harvard University and contributed scientific papers to entomological journals. In 1967, Nabokov commented in a *Paris Review* interview: "The pleasures and rewards of literary inspiration are nothing beside the rapture of discovering a new organ under the microscope or an undescribed species on a mountainside in Iran or Peru.

It is not improbable that had there been no revolution in Russia, I would have devoted myself entirely to lepidopterology and never written any novels at all."

John Cage was not only a major figure of the musical avant-garde but also a passionate mycologist, who first got into collecting wild mushrooms while walking in the Stony Point woods near his house in Rockland County, New York. His knowledge of the fungal world was so sophisticated that in the late 1950s he won five million lire on an Italian TV quiz show with mushrooms as his specialty subject. In the 1960s he supplied a New York restaurant with edible fungi, taught a mushroom class at the New School, and helped start the New York Mycological Society, a group of mycophiles that continues to host regular mushroom walks around the city and state of New York. "It's useless to pretend to know mushrooms. They escape your erudition," wrote Cage in *For the Birds*. Mushrooms are haphazard and anarchic, defying the classifying intellect. "I have come to the conclusion that much can be learned about music by devoting oneself to the mushroom."

Emily Dickinson was a plant lover and passionate gardener from a young age. As a fourteen-year-old student of botany, she assembled a herbarium of over four

Vladimir Nabokov's shoes

John Cage's boots

Emily Dickinson's shoes

hundred specimens collected in the fields and woods around the family home in Amherst, Massachusetts— a leather-bound album now held and digitized by Harvard's Houghton Library. During her life, Dickinson was better known for the beloved flower garden she cultivated than for her poetry. At her most reclusive, when gift bouquets became her way of communicating with the outside world, she continued to roam her garden at night, working by the light of a lantern in her white cotton dress. "I was always attached to Mud," she once wrote. Of the eighteen hundred poems discovered after her death in 1886, more than a third draw on her vast horticultural knowledge and imagery from her garden and the surrounding land.

I was thinking about roaming because it was August. The musician, desperate for bird action, had roamed his way to Bonaventure Island in Quebec, where he was hanging out with a hundred thousand northern gannets—noisy and tightly packed in one of the world's largest nesting colonies outside Scotland. (His departing message: "Bird-dearth depresses the brain and turns it inward, where there is only junk and loneliness! Beat the heat and kiss a bird: sally forth!") I, along with my family, had roamed up to a YMCA Family Camp in the woods of Northern Ontario.

We had been coming to our tiny cabin for ten years, trading modern conveniences for cool, sweet lake water. Any issues I had with communal dining, theme nights, bonfire singalongs (camp is an introvert's nightmare) were offset by the joy of watching my sons wander independently on the land. Most days, they left in the morning and returned—grubby, scuffed, and sometimes bleeding—after nightfall.

It was this self-reliance and freedom, so familiar to my own childhood, that I hoped to kindle. By the time I was nine, I roved freely around the neighbourhood until dark. My mother, busy minding her Japanese art gallery, left the leash long.

Thirty years later, in the same city, my children rarely strayed from our home or garden. As a parent who sat somewhere in the middle of the helicopter–laissez-faire spectrum, I wondered what it meant for their independence to be so severely compromised. I wondered and yet I found it hard to let them go. Other parents probably wondered too. Maybe we were just worried about the cold opinion of our peers if we didn't cosset our children enough. All I know is the neighbourhood was full of incarcerated children.

Having entered one of the most profoundly chaperoned moments in history, I wanted my sons to experience the kind of unstructured play that builds courage and curiosity. So late summer had become a time of jailbreak.

That late summer was also my fifteenth wedding anniversary. While my sons were catching frogs and

shooting arrows, discovering that the world outside the city could be exciting, difficult to traverse, and occasionally frightening, my husband and I took long walks through the woods.

When I met him we were both heartbroken. He was singing in the back room of a small club. I was there because two friends had insisted I leave my apartment and stop brooding over a recent breakup with a West Coast boy-poet. They lured me out of the house with promises of soul food and a change of scenery.

The man who would become my husband was lean and wiry with short dark hair. He had muddy circles under his eyes and a Grover tattoo on his arm. The room was packed with people he knew, many of them singers and musicians. In his broken state, he sang songs that were full of sultry pathos and self-deprecating humour.

We were not at our best. So I mistook him for someone else.

Here is one who is miserable, I thought, pleased. Here is my type.

On our first date he wore a dark vintage suit, which gave the illusion of a ravelled but despondent man. I thought we would have a quick drink and be on our way. I kept my knapsack on my lap, ready to leave, but the date went on and on. At three in the morning, as we danced, pressed together drunkenly, I touched his cheek, his sad stubble.

I thought it was a quick love affair, not the beginning of something that would continue. And when dawn came around and we were still together, the birds were singing. At least I think they were singing. There must have been birds in the decaying gardens and among the shrivelled flowers because, though I did not know it yet, there are no birdless days.

I did not know he would stay on, never really leaving. I did not know that between us there was anything to make a nest out of.

I soon came to know he was not a man who spun stories about himself. He did not overthink, which is not to say he was shallow or incurious. I have never met a more committed autodidact. In the time we have been together, my husband has immersed himself with doctoral focus in Yiddish study, film scoring, cantorial singing, Wagnerian opera, Russian classic literature.

Unbeknownst to me, I had found a man who tended towards optimism. He did not believe that a state of misery was optimal for an artist; he did not choose to cloak himself in tragic myths. He was not a cerebral poet like my two previous boyfriends; he did not engage in vertiginous metaphysical conversations or invest much in his own gravitas. This new man was a singer. And not a moody singer but a singer who loved

upbeat soul and handclapping gospel. On our second date, he arrived at my door with drugstore chocolate and a bottle of sherry—which he poured into two mugs as we sat down to watch *Fat City*.

Son of a single lesbian mother who had known her share of tough situations, he had been raised on a hundred lullabies. He had been raised to believe everything would work out in the end and that it was possible to feel purely happy without a precautionary chaser of sadness. The skies would not fall and you were not tempting the gods of misfortune if you did not plan for contingencies and worst-case scenarios. You did not need to fortify yourself (with thermal long underwear, calcium magnesium tablets, and university degrees) against the coming catastrophe.

He was not raised the way I was.

My goal was to stay unmarried. I did not see marriage as the path to an imaginative life. I was going to devote myself to art instead. I knew this so certainly by the age of sixteen that I once dragged my mother into a church where a wedding was under way. There, in the back pew of St. Paul the Apostle on West 59th Street in New York City, I told my mother to watch carefully. "This is it," I said. "This is the wedding I am never going to have."

We were in New York to see art. Art was something my mother and I had always shared without difficulty. We both loved to visit museums and we both loved to draw. It was because of her that I grew up with a pencil in my hand.

When we came to Canada my mother tried to learn the rules of a new culture with me. It wasn't easy, as if immigration could ever be otherwise. English remained a challenge. She messed up expressions and verb tenses. Sometimes we laughed when she mispronounced things, for example when she offered a visiting Japanese doctor her services as a Japanese-English "interrupter." But in public I could see it embarrassed her. When I was young she complimented me for being clever. Then when I became the first person in our family to attend university, continuing on to graduate studies, she called me an academic idiot. She liked to regale me with cautionary stories: about the "English PhD lady" she knew who had stupidly lost all her scholarship money gambling, or the smarty-pants lawyer at the YMCA who was despised for being arrogant. She (wisely) believed that only a fool would worship the brain over other organs.

In art, in wordlessness, we found moments of truce. In art, my mother's frustration and jealousy drained away. She could take pride in being fluent and clear.

My British father, on the other hand, could barely draw

a circle but had a way with words. He wrote things down for a living. When we were out in the world, he did not mess up his verb tenses. His public eloquence and intelligence commanded respect. No one ever looked through him as if he was a pane of glass.

But where had my father's words gone? Had they just wasted away from lack of use? I resolved to make our conversations more ranging. Less tunnel-like. Aging and illness had shrunken his powers.

Shortly after our fifteenth anniversary, I asked my husband for a song list about roamers. I wanted suggestions. We sometimes play this game where we tag-team DJ. I pick a song and then he chooses a song that is lyrically connected. The goal is to keep the music flowing without gaps. For my first song, I chose "The Littlest Birds" by Jolie Holland and let him take it from there. Here is his list:

 "Blowing Down That Old Dusty Road" by Woody Guthrie
 "Ramblin' Man" by the Allman Brothers
 "The Wanderer" by Dion
 "Born to Wander" by Rare Earth
 "Walkin' Down the Line" by Bob Dylan
 "I'm Walkin'" by Fats Domino
 "Ramblin' Guy" by Steve Martin
 "King of the Road" by Roger Miller

My mother bloomed at the age of fifty-five when she and my father parted for good. I had moved out by this point, so there was no one to keep them from fighting about everything and anything. (Their final marital fight involved a La-Z-Boy recliner.) She explored the city with new friends, flourished as a social person. For a while the anger and argument drained away and she had a calmness I had never seen in her before. She smoked pot in Kensington Market and went to open-air concerts.

My father kept moving from one apartment to another until he finally settled in two blocks away from my mother. After a brief rush of happiness, he was set back by a diagnosis of cancer and then the discovery of an abdominal aortic aneurysm. He grew more fragile while she grew rooted and sturdy.

When she first moved into her own apartment, she took a bag of garden stones with her. I found them piled in a ceramic bowl by the entrance. Stones for elsewhere. Stones for every new thing she had to learn. Stones for resolve. Stones for gravity. Stones for continuance. Stones for love. Stones for everyday beauty.

Sometimes when I visited I would gather a few and carry them around in my pocket.

My mother refused to be a nursemaid, became defiantly unnurturing, refused to cater to anyone else's desires. I stepped in to fill the breach and discovered I had a talent for it.

But the serving instinct in women is never fully extinguished. And my mother's hands are never fully empty. The other night she arrived for dinner at our house with three party-size bags of tortilla chips. For my father: a bag of light bulbs.

Twenty-five years since they parted ways, my parents are as close to being friends as they will ever be. They do not yield to traditional forms of affection or consolation, but on good days, in the playful company of the grandsons they love and when they release their respective certainties about how they have been wronged, I have witnessed a softness that I can only describe as an *understanding*.

They understand that they were both a bit broken by their childhoods, that they grew up with a sense of scarcity they took to be financial but that was also emotional. They understand they have both chosen to live, and age, alone and that my mother approaches her own old age with a practical fend-for-oneself attitude (stockpiling "senior clothing" like elastic-waisted pants and easy-to-slip-on cardigans in a closet my father jokingly refers to as "Harrods"). They abide in this mutual understanding. It is a bridge between them,

two immigrants who arrived in a third country without any further ties. On good days, it gathers into a kind of love.

From my mother, I inherited my sometimes crooked humour and independence. From my father, curiosity about the world, a desire for seclusion.

Once upon a time, I inhabited a strange, dank corner of the universe. It never occurred to me that my anxious view of the world until that point was just one frame-work. It had become so naturalized. Then my future husband came along and opened the windows and doors and nudged me outside.

I walked out of that corner as if I was following a birder down a path—moving half a step behind, looking where he looked, hearing what he heard, noticing things I had never before noticed. And at the end of our walk I looked back, realizing how decisively, how devotedly my guide had brought me through the woods.

My husband and I have built a roomy marriage. In our fifteen years, we have roamed together and roamed so far apart we might have been on different continents, living separate lives. We have saddened, maddened, and

gladdened each other; been irrelevant and essential to each other in the same moment. We have gone through phases of nest primping but also, in our distraction, allowed our nest to fall to near ruin. At least fifteen marriages between us have died and been rekindled.

In my husband I see a fellow solitary, a person with his own concentrated, if meandering, path, and while I would do anything for him and would choose his company again and again, one of the things I most love about "us" is that we protect each other's independence.

Marriage is not an existential cure and not all of us need it, though we could probably all benefit from one decent bedrock relationship. In my husband's presence, I have felt my solitude dissolve, but I have also felt lonelier than the moon, such are the contradictions of intimacy.

The gift of our love is that it has given me an earthed feeling so that I have felt free to float away. I know I can take temporary leave without its being seen as an abandonment. Pursuing a solo adventure, I have come to realize, is easier when you know there is someone half watching for your return, ready to cushion your landing and welcome you back with a song or a joke.

I worry sometimes that we have bred lonesome children. On our fifteenth anniversary, as we headed off to the woods, I found my younger son wandering alone by the creek. The lonesomeness was there in his eyes and his crouched stoop, in the space around him. He was looking for frogs after the morning rainfall. It

was a focused and solitary pursuit, so familiar to me. We waited for him to call us over or run to us, but he didn't notice us watching. My husband signalled that we should leave our son to his quest and continue.

And so we did, walking along the narrow trail, looking for birds, while celebrating everything that went into our marriage: the optimism, the fight, the humour, the mess, the faith, the forgiveness, the heartbreak, the solitude, the passion.

I had not become an astute observer of nature and I was still a bit mystified when it came to bird-finding, but I did manage to spot a pileated woodpecker in the forest that day. It was hard to miss—a crow-sized bird with a zebra-striped face and bright red crest—busy at work like a totem carver. The woods, after the rain, had a sparkling quiet quality, and as we stood under a green canopy, the slow, deep rolling sound quickly built to a loud hammering, a warning that we were too close. Walking away, we could hear the percussive pounding start to slow again. Pileated woodpeckers need large areas of woodland, just like a marriage needs space.

That night, I lay in bed in our wood cabin, tucked into my threadbare sleeping bag, and listened to the crackling of a moth and the sounds of my sons and my husband breathing.

Look at what roaming brings, I thought. From one detour, *this*.

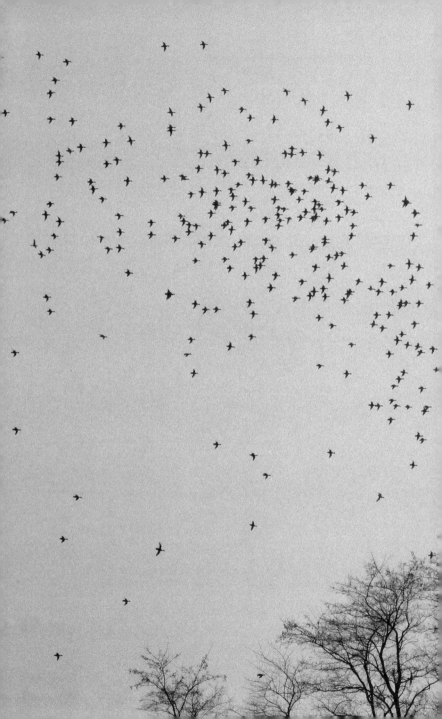

FALL

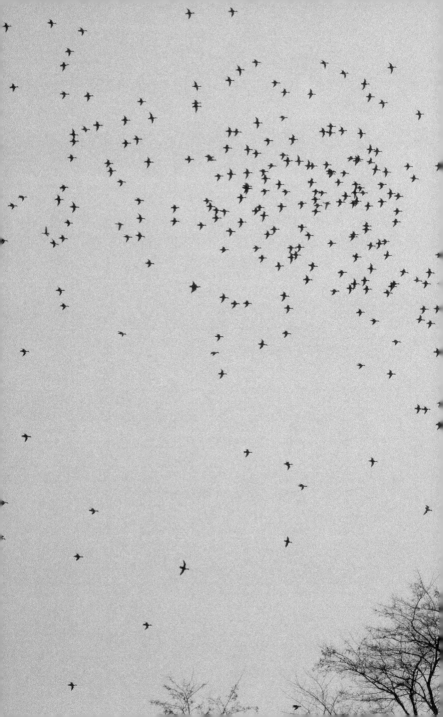

September

REGRETS

{
a JUVENILE
GREAT BLUE HERON
and a GOLDFINCH
NESTLING
}

On small but lingering regrets
and the virtues and pitfalls
of being sentimental about baby birds.

In September I rode

my bicycle to the duck ponds in High Park. It was the musician's birthday and I had brought him tickets to a Mahler symphony and a book about bird songs. The sparrows were busy singing, flitting, alighting, foraging. We stopped to watch a young great blue heron standing with a gymnast's balance on a wet log. Then we pulled off onto a smaller path.

We had been walking for a few minutes when in the near distance we spotted an elderly couple angling their cameras towards the ground. We walked over and lowered our gaze.

There, at the base of a tree, fallen from its nest, was a baby goldfinch. Its parents were whirling and swooping overhead, as if trying to instruct their grey nestling on how to get aloft.

But there was no way this nestling was going to fly. It was a mere scruff of fluff, a puff of nothingness.

The parents swooped a few more times before darting away.

A bird is born cold-blooded and for the first few days of life needs to be brooded. Until birds develop the ability to regulate their own temperature, they rely on the warmth of their parents. I didn't know if this nestling was cold or afraid, but I could see that it was trembling.

In my mind's eye, I cupped the baby goldfinch in my hands and carried it home. I had a whole fantasy that involved my nursing it to full fledglinghood. I would build a shelter for it in my study with branches and an aluminum tray for a bath. I would feed it baby bird food off a toothpick. I would build a fragrant nest with tree bark and download goldfinch songs on iTunes and play them quietly so she never forgot her roots. Then when she was strong enough, I'd release her. My husband would put together a "take flight" playlist for the occasion.

I was shaken from my reverie by tiny tweets. The baby bird had found its voice. Little crescendos of panic.

I wanted to rescue the baby bird, but the musician was opposed. The musician said it was not for us to interfere. It was wrong to risk making an outside bird an inside bird. If we had injured the bird then it would be up to us to repair the wrong, but we had done nothing. He said all young birds face hazards regardless of whether they live in urban or wild settings. He said "survival of the fittest" and, yes, it was sad but there was no point in getting sentimental about it.

The word *sentimental* got me. I did not want to seem too predictably touchy-feely or, God forbid, *female*. Besides, what would I be starting if I began rescuing stranded animals? Would I be agreeing to a future of wildlife rehabilitation?

I had known people who loved animals with a sort of raw love that was painful and toilsome. ("Every day on earth is a minefield of animal tragedies," writes Meghan Daum.) Loving animals gets in the way of things.

I decided, because it was true or because it was convenient, that the musician knew best. I agreed to leave the bird alone. My brain understood the musician's logic even though my emotions were in revolt.

One of my favourite picture books is *The Lost Thing* by
Shaun Tan. It takes place in a post-industrial landscape.
A boy finds a strange creature on a beach, and decides
to find a home for it in a world where everyone
believes there are far more important things to pay
attention to.

There is a deep melancholy in the story about what
gets left behind. On the one hand there is this hard,
streamlined world and on the other there is this boy
who is already slowed and soft enough to spot a lost
thing. (He's a bottle cap collector, so he's accustomed to
scouring the city's wayside.)

It turns out the lost thing is a bit of a portal. It's a door
through which the boy encounters other lost things,
creatures he would rarely meet otherwise. The story
shows that it's difficult to retain a soft focus in a hard,
hyper-sensory world. But it also shows there are
benefits to be found in doing so.

If you are concerned that a bird fell from its nest too early, you may try and return the bird to its nest. If the nest has been destroyed or is unreachable, you may substitute a strawberry basket or small box lined with tissue and suspend it from a branch near to where you believe its nest is located.

Birds have a poor sense of smell and very strong parental instincts, which means they will usually continue caring for their young.

AUDUBON SOCIETY

What do you regret? I regret the times I have acted with too much head or, conversely, with too much heart. I regret the times it seemed better, somehow, to hang back and not step forward. I regret, along with writer George Saunders, the tepid and timid response, the moments when another "being was there, in front of me, suffering, and I responded . . . sensibly. Reservedly. Mildly." I regret the instances I have turned to others for guidance even when I already had a hunch of what to do. I regret the part of me that is deferential, that fears being sentimental. I regret I am not more propelled by impulse, nerve, instinct.

I regret I am not better able to hide my natural sincerity under a slant and saucy wit. I regret I am not captained by science.

The word *regret* comes from the Old Norse *grāta* ("to weep, groan"). It is possible that regret is a gentle, almost pleasantly wistful way of describing the dissatisfaction I feel with the flaws in my own narrow and hesitant character.

I do not generally see myself as a weeper and groaner but I can see the possible pleasures.

Every September for many years, I have attended a secular Rosh Hashanah service where my husband sings. At a certain point in the ceremony we are asked to write our yearly regrets on little pieces of paper, with thoughts of reparation in mind. The tradition is to cast one's misgivings away on a body of water (preferably "into the ocean's depths"), but this is a progressive community so, instead, we cast them into a big blue recycling bin.

I typically distance myself from religious pieties and communal rituals but this one feels oddly satisfying. I like to spy on people and see how much they are writing down, how much "sin" they carry in their laden hearts.

My mother-in-law, who attends the service with us, never has much to write. I see this as a testament to her righteous character. She has spent her life standing up for, and alongside, others. She has marched for civil rights, helped to house and support Vietnam War resisters, spearheaded solidarity movements with struggles against totalitarian regimes in El Salvador and Nicaragua, and continues to champion the rights of Palestinians. She has been a lifelong, tireless fighter against economic, gender, and racial injustice.

Her heart is weep-less and groan-free.

Sometimes I worry about our collective hearts. I worry about the big things we may one day regret together. I worry, along with British nature writer Robert Macfarlane, that "we exist in an ongoing biodiversity crisis—but register that crisis, if at all, as an ambient hum of guilt, easily faded out."

Would it be deemed maudlin or diabolically unscientific to extrapolate from a fated goldfinch to the current extinction rate for birds, which according to Macfarlane "may be faster than any recorded across the 150 million years of avian evolutionary history"?

I don't think there is a ritual big enough to cast this degree of regret away.

But the goldfinch: I would like to have surprised myself. I would have liked the chance to take part in a small triumph against death.

If I focus my intentions now, will I be spared remorse later? Can one build hedges against regret? Would a life protected from all regret be considered virtuous or monstrous? Can one experience bone-deep regret for another person's choices—a sort of proxy or companionable regret for those most connected to or similar to ourselves? Is this a productive feeling?

Every now and then I am contacted by someone who wishes to thank my father for his past work. The other day a man wrote to my father (via my email address) to express gratitude for something he did nearly fifty years ago: "I have known of you since December 1970 when you conducted an interview with my father when he was an American prisoner of war in Hanoi, Vietnam. I was 15 years old then, and more aware of war, foreign policy, and their impacts and implications than the average teenager. I appreciated the contact you had made."

It fills me with pride to think of my father's professional contributions. Still, a part of me wishes he had taken time to look around, that he had not conducted his life as a race to the finish. I regret he took many of life's circumstances, including the

positive ones, and shot them through with skepticism and dread in an attempt to inoculate himself against disappointment.

I worry there might be a cost to living a defended life and moving through the world as an unstoppable self. The cost of joy.

When I was small this is what I noticed: my father late at night fighting with his typewriter, parrying with words. I did not know what the quarrel was about but I knew it was relentless. Something needed to be said. And then one day, many months after the fighting had ceased, a book arrived.

Even now the sound of typing is the sound of living is the sound of home is the sound of something missing.

I both love and regret how similar we are.

That evening, as I imagined a box and inside the box, a very small goldfinch nestling, I realized my actions needn't have been drastic. I could have simply tucked the bird into a protected shrub away from foot traffic and dogs. The parents might have continued to care for it until it could fly. I could have notified park staff. Instead, I had relied on someone else to demonstrate leadership. I had been won over by the musician's laissez-faire attitude. It had seemed convincing. And

maybe, probably, he was right. "The goldfinch isn't a species of concern," he later insisted. "It's thriving. If it had been a rarer bird, say a Connecticut warbler, I probably would have done something . . . but I still feel that we should never, ever handle wild birds."

Maybe it would be better to let out a gentle sigh at the transience of the world and carry on.

But there was also a chance he was wrong.

"We have to work to find that first, true impulse," writes William Kentridge in *Six Drawing Lessons*. In our waning, unreliable memories, outrage is too easily lost. "We are left with something closer to regret. Regret at what happened, but also regret at our inability to hold onto our feeling."

When I asked my mother-in-law if she had ever doubted or regretted her choices, she said: "I have never regretted speaking out, sometimes to my disadvantage. Not all of my choices have been well thought out. But that impulse to intrude made its mark when I was very small and it pulsates to this day."

She then added: "I think regret is something like lost hope. Taking action generates hope."

I would have kept the bird in my room and fed it moistened seeds and mealworms. It would not have been heroic. I could have made a fuss. I could have risked being a cliché of earnestness, risked trying and failing.

Deep down I think I knew the remorse would not be large and crushing. It would be small and manageable, just a tiny bird, embarrassingly little. Not a crisis. And that's why I regret it. Because the attitude that somehow, without our acting, the little things will take care of themselves does not ring true anymore.

October

QUESTIONS

{

MORE DUCKS
and a WHITE STORK

}

On the necessary
unnecessaryness of art and birds,
especially in times of crisis.

I didn't feel

myself. It was October, and as the planet tilted into shadow the birds were shouting at me from the trees. But my heart wasn't really with the birds. I was thinking about my husband hunched over his computer, tracking news of our friends, imprisoned in Egypt for more than a month and a half.

For a time the story was international news. Two Canadian citizens on their way to a humanitarian medical mission in Gaza, caught up in a security crackdown during a stopover in Egypt. I won't belabour the facts except to say that our friends were witness to a massacre of unarmed protesters by the Egyptian military, and that they—a Canadian filmmaker and a Canadian doctor—paid the price for stepping forward to assist the wounded and dying.

They worked for six hours in an improvised field hospital at a nearby mosque watching the mosque's carpet turn from green to red. By the time they left, they had seen forty people die.

The news told us certain important things.

Detained without charges along with 600 others ...

38 men in a 3 m x 10 m cell ...

They have started a hunger strike to protest the arbitrary nature of their detention.

But we still had questions. Was it true that they were sleeping on a concrete floor in a cockroach-infested room with thirty-six other men? Had they recovered from the beating they endured upon arrival in prison? As we worried for their physical and mental health, bits and pieces of information reached my husband, terrible details written in letters smuggled from prison.

We felt awakened to the knowledge that this was the kind of event that happened all the time without attracting much attention from those not directly affected. Massacres of peaceful protesters, acts of arbitrary arrest and infinite detention, innocent people tucked away in the world's most hidden corners, lost to the abyssal unknown.

My father supported us during this time. He offered advice, journalistic contacts, interpreted the news closely. He rallied, as was his way, when things got tough. He had wisdom we did not possess. His profes-

sional experience included coups, revolutions, massacres, genocide.

I remember that during our friends' imprisonment a white stork was captured and jailed in Egypt under suspicion of being a spy. Actual investigation revealed the alleged spy camera was a tracking device used by French scientists studying the bird's migration patterns. But it did not escape us that the Egyptian junta had reached new levels of paranoia.

"Are they going to be freed soon?" our sons asked, weekly, daily, hourly.

Along with countless others in the Toronto arts, humanitarian, and medical communities, we poured our energy into securing our friends' release. If there was optimism to be felt, it came from this groundswell of activity and love.

"What sort of thing is a coup?" my younger son asked one morning. To his ears it sounded sweet and soothing. *Coo.*

I didn't know how to respond. Every day as a parent is full of minute calibrations, wondering what I am giving, what I am taking away. I know enough to know that just because a child takes things in stride, seems

able to confront difficult events in the world, doesn't mean he is impervious. What to do with a child who is so canny to crisis?

"A coup is the bowl they used as helmets in the War of 1812," said my elder son. This seemed to satisfy.

It is not unusual for my younger son to turn to his brother for answers. On stormy days, during tense moments, I've seen him huddle against his brother as one might nestle under a canopy. He looks to him for a proper read on any given situation. He needs his brother's cool compass just as I need my husband's calm and sunny nonchalance. Each of us has our own lodestar.

A household psyche rests in delicate balance.

My bird appreciation dwindled. At least for the time being, it felt unnatural. I knew birds were not trivial. They were constantly chirping, and what they were saying, or what I heard them say, was Stand up. Look around. Be in the world.

But I felt a certain embarrassment, and this feeling quickly slipped into a sense of shame. Watching a wood duck on a pond early one morning brought me to tears. I was quaking with cold, watching a slow swirl of mist on the water. I tried to explain to the musician

what I was feeling, that birds were diverting my attention from more important matters, and he listened kindly without for a moment making me feel overwrought or rolling his eyes at my unfashionable hand-wringing.

The musician's priorities were not my own. As a songwriter and bird photographer he created work that was full of heart and humanity, but if asked to deliver an opinion on a political issue involving humans, he would generally say: "That's not a topic that concerns or interests me."

Still, he understood the essence of what I was saying. He was, at the very least, familiar with the feeling that making art—funny art, beautiful art, tender art, boring art, fierce art, humble art, lofty art, existential art, "political" art (or, in my case, art about the trials of making art)—was a fairly limited and potentially narcissistic thing to be doing with one's time on a fucked-up planet.

Leaving aside the grand defences—that art offers an alternative value system, serves (in art critic Dominic Eichler's words) as a "wayward conscience in an unconscionable world"—we both agreed that in functional (stanching the wound, stopping sea-level rise) terms, art was fairly superfluous and frequently pointless. Some days this pointlessness was fine and even the point, but other times it felt dubious.

So, even though the musician did not spend much time considering the whole "who/what should my art serve" question, he could appreciate what I was saying: that being an artist did not stop you from falling short as a citizen.

But something very specific was bothering me. It was a sense of hokeyness. That by focusing on subtle and small awakenings of awareness, I was enacting a cliché of nature appreciation. I was embarrassed by birding's provenance, its air of elitism and elegance. As with most Western leisure pursuits, the study of birds and natural history blossomed during the Victorian era. The pleasures of genteel liberal culture and high-minded recreation floated upon a backdrop of brutal imperialism abroad and growing inequities at home. While the majority of people in England and the colonies were still surviving on limited resources, worrying about rats and rickets, not to mention the plunder of land and body, white male naturalists were traipsing about the countryside collecting eggs and birds' skins and getting worked up about the varied and colourful wildlife they saw.

A fact: if you watch life through binoculars, your vision is naturally blinkered.

On the day we learned our friends' detention could be extended up to two years without formal charges being laid, I sensed my older son outside our bedroom, listening to our whispered conversation. Through the half-open door, I recognized his posture of gleaning from years of my own chronic eavesdropping. When he noticed me noticing, he slid down the stairs.

What was partially true during the Victorian era remains partially true today: people who are busy struggling for survival do not observe birds for aesthetic pleasure.

Hence a common if unfaceted notion about nature and beauty: that it is permissible only in times of stability and prosperity, that it is essentially contemptible and evasive to contemplate the pretty surfaces of the world while people suffer. This sentiment is encapsulated in Bertolt Brecht's poem "To Those Born Later." He writes: "What kind of times are they, when / A talk about trees is almost a crime / Because it implies silence about so many horrors?" Brecht's words (echoed by Henri Cartier-Bresson a few years later: "The world is going to pieces and people like Adams and Weston are photographing rocks!") reinforce the idea that a love of nature is a middle-class luxury, an excess to be distrusted. To "talk of trees," to partake of

the kinds of self-indulgence and self-delightedness for which the privileged classes are known, is an offence.

But birds do not stop flying and art does not stop getting made. During their detention, our friends applied themselves to making their clammy sauna of a cell more habitable. They were crafty. They made glue out of macaroni and fashioned hooks to hang personal items from. Their days were so dull, so ordinarily horrible, that they applied themselves to problem solving. They designed a way of showering with a sawed-off Fanta bottle using cold and earthy Nile water. They held nightly lectures, where every cellmate was encouraged to share some expertise ("How to improve your CV," "Films about prison") to ward off despair. They refused to let prison rob them of their self-expression, sense of solidarity, and vocational instinct. The filmmaker sketched portraits of thirty-four of the prisoners on cardboard packaging. He made art because he is an artist and that's what artists do. The doctor, meanwhile, treated the sick and injured because that's what doctors do.

One evening my sons helped make a sign for a Tumblr "portrait petition" directed at the Egyptian and Canadian governments. They wanted to add their photo to the wall of pictures calling for our friends' release.

They sipped lemon soda through straws as they painted the words *PLEASE FREE* ... My elder son's tone had a fatherly quality. "Let's add penguins," he said.

"Penguins?" my younger son repeated. His tone was hard to read. He either admired his older brother's ingenuity or thought he was a numbskull for being so bloody cheerful. It was hard to decide. I don't know if he did.

Months later, I found myself reading about Rosa Luxemburg, who in 1916 was "preventatively" imprisoned for two and a half years for her revolutionary and anti-war activities. Locked away, Luxemburg took particular pleasure in watching and listening to birds within and beyond the prison walls. In letters to friends she mentions reading a study of bird migration and describes her encounters with sparrows, a nightingale, green finch, chaffinch, and blue tit. Keen-eyed, clinging to the birds, Rosa lifted her spirits by singing the Countess's aria from *Figaro* to an audience of blackbirds. In her eccentric and uncompromising letters, I saw how bravely and closely Rosa observed the world from the small space of her prison, how the birds sharpened her microscope eyes.

I also saw that many of our commonplace notions about beauty are simply wrong-headed—that to say

that a love of nature is a function of privilege and
wealth, that a delight in small things is incompatible
with a passion for justice, is untrue and patronizing to
the struggling and the poor. Rosa's letters push back
against this assumption by showing how far nature
could help, how it had historically helped, to fulfill
"the potential dignity and worth of human conscious-
ness." She was not naive. What Rosa believed was that a
commitment to social justice, far from being incom-
patible with aesthetic experience and sensual pleasure,
demanded it—that politics has to be about harnessing
the libidinal and the beautiful and not only about
abstract categories.

Through her window, I found a frame to contain
both the world of nature and the world of politics,
beauty and conscience, small gestures and big actions.

I am inclined to exaggerate the balance of traits in my
family, so let me qualify: my elder son tries to be a
good canopy but he is not perfect. Sometimes he furls
himself up, withholding shelter. Sometimes he feigns
annoyance and *Weltschmerz*. He can be grumpy, short-
tempered, aloof.

But behind any surface withholding is a base of
solid, protective love. I cannot count the number of
times I have watched him extend a hand to hold his
younger brother—the way my mother once held my

poncho, the way the siblings of the filmmaker and doctor held them in their absence.

♪

I discovered there were other prisoners who developed an affinity with bird life—from the Birdman of Alcatraz to the so-called bird men of Warburg. (The latter met while birdwatching in a German prisoner-of-war camp and went on to become founding fathers of the nature conservation movement in Britain.) I sifted through prison letters and diaries (including those written from Alcatraz and Warburg) describing the sparrows in the rafters of an old cellblock, the snowy egrets nesting in the shrubs, the crows casing the perimeter fence, the wood pigeons flying through heavy iron gates.

The birds equalled the deepest longings for release, the desire to claim a better and bigger life.

In *Man's Search for Meaning*, Austrian psychiatrist and Holocaust survivor Viktor Frankl writes: "One day, a few days after the liberation, I walked through the country past the flowering meadows, for miles and miles, toward the market town near the camp. Larks rose to the sky and I could hear their joyous songs. There was no one to be seen for miles around; there was nothing but the wide earth and sky and the larks'

jubilation and the freedom of space. I stopped, looked around, and up to the sky—and then I went down on my knees."

I spent a few days listening to the music of Olivier Messiaen, who wrote what music critic Alex Ross calls "the most ethereally beautiful music of the twentieth century" while incarcerated in a prisoner-of-war camp in Görlitz, Germany. Messiaen notated the birdsong he heard while in detention and incorporated its patterns into his music. Jarring, discordant chords followed by long silences.

Rosa was not the only caged bird lover. But in her letters, I found something affirmed: birds are necessary. There are so many important things to write about—a feeling that was heightened for me during our friends' incarceration. But birds kept me going, just as music kept my husband going when he was reduced by fatigue and worry. I watched the birds, anywhere they happened to be, even birds I had seen a thousand times. They limned how high the sky stretched, how infinite and intense the blue could be, how vast the non-human world. I listened to the invisible ones, tucked into the eaves or branches of trees, hidden beneath an underpass. Their noisy and happy chirrups seemed to grow more insistent, as if enlarging themselves in counterpoint to the news from Egypt.

"In two days? In three days? In a week? When will they get out of jail?" our sons asked.

Over weeks of listening to my sons' conversations, I pulled out a thread of hope. It seemed that watching people rise up in the face of a terrible situation, and seeing their parents do something about it, and knowing there were age-appropriate "artivist" things they could do, diminished their sense of fear and fatalism.

Then miracle of miracles, our friends were released. After being held for fifty days without charges, they were permitted to leave prison.

When my younger son heard the news, I saw him proudly eye the Tumblr petition sign he and his brother had painted and photographed. It was leaning against the kitchen wall—the words *PLEASE FREE OUR FRIENDS NOW* punctuated by two blue, blobby penguins.

Many months after the doctor and filmmaker returned to Canada, I asked them if they remembered hearing or seeing any birds when they were in prison.

Here is what the doctor said: "What an amazing question. The honest truth is that I don't remember. It's not part of my memories of jail. When you asked and I went back to the day, I can't help but remember birds. The sight of birds. But not their sounds. And not in our first jail cell (first 30 days), but in our second (last 21 days). How could I have seen them but not heard them? It makes me think that my memory is false."

The filmmaker wrote: "I don't remember birds—and I think it was because there were so many cats—lots of cats—wild scrawny nimble kittens, smudges of fur living on garbage—there was an orange one that would leap up and hold on to the grille of our door, whenever one of the prisoners came back from a family visit with chicken . . . In our second cell, when we'd be let out for exercise, we would dawdle in the hallway, staring out past the walls at the high-rises—and the balconies— hoping we'd see a living person—fantasies of communicating some sort of secret semaphore across the half kilometre that separated us—but there was never anyone there on the balconies. It was like birdwatching I guess—waiting vainly without binoculars for the sighting of a rare bird. And then one day she was there—in a pink headscarf, smoking a cig on the roof, taking a break from taking in the washing. One of our cellmates who we nicknamed Shiny was a bit birdlike—a big clumsy teenage ostrich, pecking at

218

us. There was one bird that made the news. It was a stork that did not understand the intricacies of international borders."

In a short but stirring art video made a few weeks after their release, the filmmaker shows a series of hand-drawn flashcards he created in detention as a retroactive diary of their experience. *Prison Arabic in 50 Days* acknowledges that their stay, while awful, was relatively short. Because they were Westerners, their circumstances and prospects were better than those of their Egyptian cellmates. The video is dedicated to the many who campaigned for their release and honours the many who are still behind bars. One flashcard depicts a wristwatch, accompanied by the word, in Arabic and English, *Khalas*. Enough.

It is possible that my sons developed a lofty sense of their powers of political persuasion during those terrible weeks. But I have no regrets if they think they are presto invincible, or if they believe creative acts can double as activist manoeuvres. No regrets.

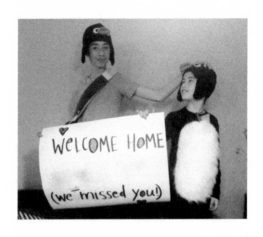

Art is a lure to the difficult. The beautiful is a gateway to the urgent. In my desk drawer, the poem Adrienne Rich wrote in response to Brecht, "What Kind of Times Are These."

> why do I tell you
> anything? Because you still listen, because in times like these
> to have you listen at all, it's necessary
> to talk about trees.

November

ENDINGS

{
GOLDENEYE DUCKS,
LONG-TAILED DUCKS,
a KESTREL,
and a
PEREGRINE FALCON
}

On becoming guideless and learning
to let go of the idea of being led
because there is really no one person
who can give you a map for living.

The last leaves seemed

to turn and shiver and fall at once. The musician and I were walking around Humber Bay Park, past the pressed brown grass and the dusty green plants and the crowds of darkened flower nubs. I could feel the park coiling into itself, slowing its pulse and reducing its palette, preparing for the cold days ahead.

The musician felt far, far away, walking slightly ahead of me or beside me, but not with me. He had never in the months we had spent together ever made me feel uninvited, but now as I walked in his shadow, quietly following, watching his head dip with each step, as if tracing the rhythm of some private thought or song, I felt like a lousy tagalong.

A few days earlier he had told me in an email that he thought he might be losing interest in birds. I dismissed it as a bad mood, the symptom of a slow season. But now I was wondering if he really meant it. He gestured half-heartedly at a cluster of long-tailed ducks and a few goldeneye ducks. He pointed to a kestrel perched on a lamppost, bobbing its tail. He was playing the role of a bored and dutiful tour guide.

With a few exceptions, the park was mostly barren and birdless, which didn't help. It merely contributed to the empty feeling that was starting to yawn inside me. It wasn't just that I had lost a birding companion. His enthusiasm had made me believe in the city's wrecks and barrens. He had added a shine to the dull wastelands and added magic to shores clotted with ugly condo towers and building cranes. I had relied on his gusto to elevate my interest. Now that he was elsewhere, I felt the city lose its fairy-tale lustre.

I felt the musician lose some gleam too, as if some internal rheostat had been lowered. Was it just a bad day? Or was it a bigger crisis? Could a passion just fizzle out?

We walked to the lake and stood there for a while talking and watching a couple of mallards drift along the shoreline. He said that his sudden overexposure to bird photography had left a bad taste in his life. (The equivalent, he said, would be if he only spent time with musicians who were into "superslick commercial music.")

He said he needed a break.

He said: "I'll be surprised if I go for more walks in Toronto with my camera."

"I don't need it." "Special trips are different. Those I need." "It's just going to get harder in Toronto as we lose more and more space for birds." "The birds are going to start leaving."

It was difficult to argue with this last point, especially standing in a limbo of new real estate, on a day that had been almost devoid of birdlife. In fact everything he said was understandable. It was the *way* he said it—hard and defensive, protesting too mightily—that was unconvincing. I watched his eyes settle on a duck wading a few feet away and noticed a slight wistfulness. "You know," he said, with a sigh, "even though it's over I'd be surprised if I saw the feather pattern of a female mallard in ten years' time and didn't swoon."

Then the conversation shifted and the musician mentioned he was back in the studio recording his album. He was excited but he also had those "bonkers feelings." All his energy was going into stirring and reawakening his song muse. He felt doubtful about his music but he was moving forward, doing his best to un-believe the negative voices in his head.

And then I understood. For most of the year I had followed the musician. As we shared thoughts on art and I talked about how birds were making their way into my work, he had disparaged his music, acted as if it didn't exist. Now that he was transferring his feelings back to his music and re-entering that dark, luminous place of creation, he was moving in the reverse direction—tidying away the birds.

It was possible that he could care passionately

about only one thing at a time. Or that he needed only one passion to feel order and purpose in the universe. But I had difficulty believing that birds and music were just transposable distractions, simple ways of "passing the time," as the musician was now explaining to me. Were they really just different but equal forms of "anti-death medicine"? Was that really what he believed? That our primary impulse in life was to fill the holes left by being human, to divert ourselves from life's central sadness? Did he not need music and birds for reasons beyond solace? Were there not also intellectual, ecological, and imaginative reasons to go birding?

I was happy the musician was finding his music again. I was rooting for him. I was entertained by and worried about his excited speech and the evangelical sheen in his eyes. I wondered if he could make his album without trying to please anyone. If he could complete it without withering at criticism or flying off on the wings of ecstasy when he received praise. I wanted him to be able to transfer to his music the goodness—*the free and smooth and happy feelings*—that came from birding.

For me, birding and writing did not—and do not—feel interchangeable. Birding was the opposite of writing, a welcome and necessary flight from the awkward daily consciousness of making art. It allowed me to exist in a simple continuity, amid a river of birds and people and hours. The stubborn anxiety that filled the rest of my life was calmed for as long as I was standing in that river.

The musician and I walked home along the waterfront boardwalk until we reached a stretch of beach known as Sunnyside. At its peak, between 1922 and 1955, Sunnyside was the festive heart of Toronto. Home to balls, bandshells, jazz concerts, tightrope walkers, and even a year-round amusement park, Sunnyside was the place Torontonians came to play.

But then we abandoned it. We got caught up in the rise of car culture and the building of expressways (which bisected the waterfront and tore up the amusement park lands). We choked the beach off from the rest of the city. We started heading north in search of "truer, wilder" nature. Sunnyside became less desirable as we poisoned the lake.

I don't know if it's possible to walk around Sunnyside and not feel the ghosts of dashed dreams. A "party is over" mood pervades, especially in the desolate months of winter. I felt it in the old Bathing Pavilion with its massive columns and classically arched main entrance: a beauty queen stripped of her crown. The facade's peeling paint and crumbling stucco had left it looking gloomy and neglected. The grounds seemed designed for historical film shoots and elegiac thoughts.

On that cold November afternoon, I stood on the boardwalk overlooking the deserted beach and tried to picture a bunch of rowdy bathers vying for a spot of sun. I imagined men in straw boaters and women with bathing skirts down to their knees. I wanted to conjure

some magic from the faded festive architecture—a rising raft of balloons, a carny shouting, "Step right up, boys, the first ball's free." But mostly I wanted to see a bird, a bird that would make the day seem less vacant and the space less depleted. The musician and I were nearing the end of our final walk together.

Then, suddenly the musician was making his way towards the lake. He was beelining for the concrete breakwalls built to help calm the water for swimmers. I hurried to catch up. There were a few untagged trumpeter swans on the beach, but the musician ignored them and kept moving towards an odd crow-sized silhouette in the distance. Was it a juvenile cormorant or maybe the kestrel we had seen earlier?

It was neither. What we saw before us was a peregrine falcon.

Top of the food chain, fastest animal on earth, able to dive for prey at the speed of 320 kilometres an hour. There it was. A bird that had been nearly obliterated by the effects of the pesticide DDT, a bird that had made an incredible comeback since the 1970s thanks to recovery efforts, a bird that generally preferred to perch high up (scouting for potential prey from clifftops or the window ledges of skyscrapers) perched at eye level on the breakwall.

An odd and ancient hush. Stunningly still. It possessed an earned stillness, the sort that follows soaring flight and aggressive muscular effort. I raised my binoculars and gazed at its slate-blue back and the barred feathers of its chest, its yellow feet bright

against the drab concrete perch. What I felt most was its self-containment, an aura of separation and indifference.

I lowered my binoculars and noticed the musician was no longer standing beside me. My guide, who I believed to have been swallowed up by other realms, whose bird love had allegedly faded, had waded into the cold, murky water. There he stood, in a lake that was gradually being restored through recovery efforts, feet sloshing crazily in his leather shoes. I felt my eyes get tingly and hot as I watched him move ardently towards the bird.

I knew the peregrine falcon wasn't there to symbolize hope and resurrection. If it had a message, it was complicated, saying something about the cycle of humans damaging the natural world: the declines, the failures, the modest recoveries. Inside my own mixed emotions was a little portal of understanding and an invitation to feel what writer-activist Rebecca Solnit once described as an awareness of "two streams" of loss: on the one hand, there was a revived bird on a restored lake, a sense of things that had been saved from slipping away (imperilled species coming back from the brink); on the other hand, there was the pull of things that were simply "vanishing without replacement."

Life and death. Survival and extinction. The common and the rare. The robust and the disappearing. I had come to see that birding was about holding opposites in

tension. It elicited a twoness of feeling—both reassuring and dispiriting—especially in a city where so little landscape had survived modernity's onslaught. In that twoness was a mongrel space between hope and despair.

I had learned, on my journeys with the musician, that beauty could exist in the most scarred, phenomenally impure places. I had witnessed how the usual story of urbanization, of humanity's estrangement from nature, was being revised through rewilding efforts. I had met city birders and local conservationists who were using a different environmental voice, one that could (in Naomi Klein's words) "speak to the wounded, as opposed to just the perfect and pretty." It was a voice that looked around the city's most blemished and broken places and said: "There is something left to love."

What I discovered about birding was that it was not a rosy or cutesy practice. It did not offer a sentimental overview of the natural world or a flight from consciousness. In fact, it was often the polar opposite. Sometimes in the quiet moments of waiting or walking in a place empty of people, in vacant lots where the damage and hideous underview of the city was not to be denied, I felt a loneliness that struck me to my core. Why would anyone invite the experience? And yet there was also something undeniably uplifting in catching glints of life, sharing sightings with strangers. There was grace in witnessing the constant aerial motion and nervous twittering of common species. In

the coldest months, when gloom seemed natural and even predestined, it was nice to see there were birds creatively opposing it.

When the damp reached our bones, we decided to leave. The musician, who had been crouching down on the beach, photographing the peregrine falcon under the big empty sky, packed away his camera. We headed north, away from the lake, crossing the pedestrian bridge over Lake Shore Boulevard. Roaring sound of tires, bright rectangles of space between the slats of the railing. The arch of metal separating me from the sky felt unusually slight.

I called my father when I returned home. I tried two times before I finally got him on the line, fresh from a shower. We had our usual brief but newsy conversation. Big news, small news. A veteran war reporter cannot stop paying attention to the world. Through the worst moments of aging and illness, what has rescued my father is a bottomless hunger for headlines and a complementary sense of his own minor scale in the larger scheme of things. He inspires me in this way. It didn't matter that our conversations had become more halting, or that when we talked I could feel him thinking himself through the talking, occasionally receding as he wrestled with words that were themselves receding. It did not matter that he forgot words

like *ceasefire* and *sanctions* or the names of countries he had visited as a foreign correspondent. Yes, the person who had ignited my enthusiasm for language was losing his own, but what mattered was the effort. My father was a survivor, working-class child of the Blitz, dodger of obstacles. Like a stammerer who reaches for the synonym and learns to become more adept at sentence construction, I felt him dance around the gaps.

My father brimmed with effort. As we spoke that day, I knew that wherever he was seated in his small apartment, on the sofa by the window or at his old mahogany desk, he was nicely dressed, cleanly shaven, freshly combed. In his kitchen: stacked plates and clean glasses. In the closet, stacked towels and folded linen.

I recognized the DNA of this effort in myself and others close to me. I recognized the valiant, creative, sometimes futile micro-stands we take against the myriad forces that upend us like bad pranks. Life is just this way, filled with embarrassing, run-of-the-mill, sometimes awful obstacles. If we're lucky we learn by watching others make it through, still standing and smiling. If we're lucky we learn to live in a flux of adaptation. In the twoness. Flickering between ease and difficulty.

My father had faltered and rallied, declined and thrived. Even at his weakest, when he had depended heavily on me, I had also depended on him. This give-and-take was

all the more meaningful for two people who were, are, pridefully and painfully self-reliant.

When my father and I ended our phone conversation that day, I found the navy blue Oxford dictionary he had given me for my seventh birthday. I confirmed the word *peregrine* means "having a tendency to wander."

It clearly fit the peregrine falcon, which is known to travel vast distances, but maybe it also fit me and this book I was writing about being a little lost, this book of inward and outward travelling to the verge of life.

The musician sent me a photograph of the peregrine falcon we had seen. He was still feeling exhilarated by the day. His excitement made me wonder if his talk of "disavowing birds" was just a ruse.

It then occurred to me that perhaps he was letting me go. In great Hollywood tradition, I thought: maybe we are having our own little *Searching for Bobby Fischer* or *Karate Kid* moment. Maybe my guide (who had never sought acolytes, who had never lectured me on what to read, who had never, for that matter, been explicitly guiding) was creating the conditions for me to guide myself.

Among the things the musician taught me, directly and indirectly:

1. There are no big reasons to live. Just little reasons.
2. Make leeway for chance. Sometimes you don't want to be driven to a point. Sometimes it is exactly when we lose our bearings or take a detour that life really gets going.
3. The best songs don't always come from a locatable place. Sometimes they seem to come from nowhere or everywhere—for example, a thicket of sound under a parking lot overhang in the middle of a long winter.
4. Birding is more than an activity. It's a disposition. Keep your eyes and ears and mind open to beauty. Look for birds in unprecious places, beside fast-food restaurants and in mall parking lots.
5. Good shoes go a long way.
6. Never carry more than you need.
7. Just a nice stroll through a park is enough. Walk everywhere in the city and you will find you don't need to traipse up Everest or schlep to Kalamazoo to go places.
8. There is really no one person who can give you a map for living. But this may not stop us from wishing there were. It would be nice if there were such a person or such a book, with a list of things to do and avoid, definitive directions to take and not take, cautions to navigate by. Act this way. Live that way.

What he really taught me was that the best teachers are not up on a guru throne, doling out shiny answers. They are there in the muck beside you: stepping forward, falling down, muddling through, deepening and enlivening the questions.

I am grateful for the loop of time we shared together. I know I am not the only person he has affected. The musician changes the way people look at birds. Following a bad breakup several years before, he confronted his ex-girlfriend in a bout of self-pity and said, "You'll never remember me." And she replied: "You're wrong. You've given me a gift. I never used to notice birds and now I think I love them."

When he told me this story, I thought: *Now I think I love them too.*

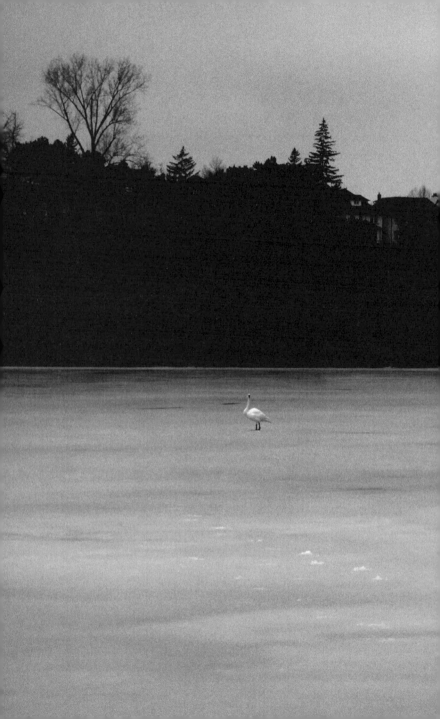

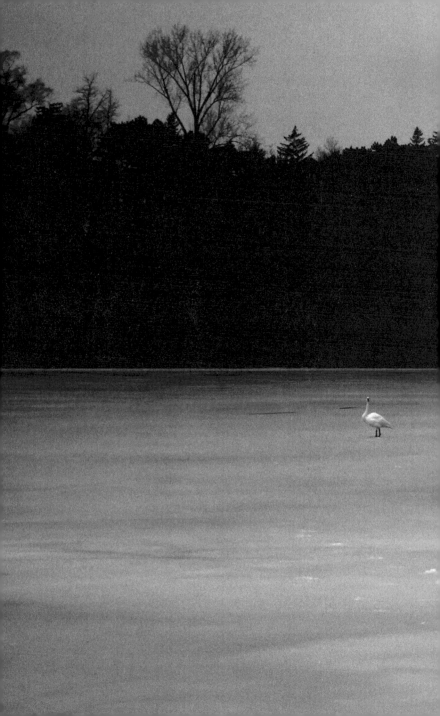

December

EPILOGUE

On living long
and feeling both little and lavish—
with birds, art, love and death.

Many years ago,

on the eve of my marriage, my father gave me a lacquer box with a black-and-white photo inside. It showed my father from behind peering out over a lunar landscape.

Written on the back of the photograph were the words *This is a very historic photo of a time of horror and happiness. In September 1969 I travelled from Hanoi, Vietnam, to the border with the South—the first television correspondent to do so. What I saw no one in the West at first believed, countryside bombed so totally that it looked like the craters of the Moon. When I returned to Hanoi (travelling at night to hide from the bombing), I vowed I'd do a television history of Vietnam some day to "repair" the damage. That same day in Hanoi I received wonderful news that forever altered my life: a telegram from Mummy saying you were on your way!*

My husband thought it was an interesting but strange wedding gift. On the one hand, there was the photo— black marks of bomb impacts on the ground. On the other hand, there was the refined lacquer container, subtly inlaid with mother-of-pearl, a reminder of my father's simple yet elegant taste. Horror and happiness. After years of observing my father, however, I didn't see it as strange at all. Intense, maybe, but not, in the out-of-character sort of way, strange.

In the months and years after our wedding, I kept going back to that box. It seemed, in that manner of certain keepsakes, to offer some basic truth: life is a mixture, a combination of opposing elements.

My father has always been drawn to life's craters. As a war reporter and later a documentary filmmaker, he made a life of doing what most sensible people avoid-ed—he rushed towards disaster. He faced forward when others would have looked away.

He chose war because it allowed him to step into a meaningful narrative. He chose war because it was a good story and it held a sense of camaraderie and because he felt he could make a difference. Or maybe he chose war because he saw in the brutal act of fighting a clear-cut expression of the brutal act of living. Or perhaps the reason he chose war could be summed up in a quotation from psychoanalyst Ernest Jones, Freud's close colleague, who once noted "how

very much easier it is for the human mind to tolerate external danger than internal dangers," a remark Jones felt to be supported by the decrease in suicides and mental illness in London during the Blitz.

I don't know why my father, a physically gentle and peaceful man, chose war, but I do know the choosing sculpted aspects of his personality and shaped his view of human nature. He accepted loss and sorrow graciously, but he never learned how to accept happiness. My father secreted these notions into my blood. He secreted words into my brain. I moved forward in the marks of his footsteps. There was safety in choosing a state of sharpened and fortressed caution over the hazy and vulnerable state of hope. Prepare your mind for the worst, my father taught me, this is how you stay alive. Danger and misfortune, disappointment and embarrassment, are always lurking.

But in his illness, when there were genuine medical underpinnings to support his pessimism and my own, the question of how do you stay alive seemed insufficient. It became more important to ask: How do you live?

My walks with the musician were taken with living in mind. They took place against the shadow of my father's illness. The emotional chiaroscuro of this time brightened an awareness that doesn't, in my life, get lit

up very much. The birds circled overhead, circled around our bodies, circled around each other. I learned to listen to them. Cheerily, cheer up, cheer up, the robins said with their robin accents. Birdie, birdie, birdie, yelled the cardinals, upping the ante.

I'm listening to them right now as I write. Sometimes it's just unbelievable, the racket they create, as if they were competing with all the other noise in my neighbourhood. Then it all stops and I hear a dull clank of bottles. I look outside and see a very old Asian woman with a quilted jacket and a wool hat pushing a cart full of empties up the street. Last year she brought us a seedling tomato plant to thank us for putting our bottles aside for her. Rattle, rattle, a steady flow of seniors with carts and bags of bottles continues throughout the day.

The birds tell me not to worry, that the worries that sometimes overwhelm me are little in the grand scheme of things. They tell me it's all right to be belittled by the bigness of the world. There are some belittlements and diminishments that make you stronger, kinder.

My father taught me to prepare my mind for the worst but he also made me unafraid to enter the unknown. The craters, which introduce you to the pain of life, which teach you about the un-solidness of ground, can embolden you. In my case, they were a portal to my

becoming a writer—and a mother who sees that her younger son is not entirely free from these inheritances.

"If I have the energy I'd like to make a final documentary about Vietnam," my father said to me recently. "It will be set on the Ho Chi Minh Trail."

He explains that five decades after American warplanes plastered the Ho Chi Minh Trail with bombs, a remote untouched portion near Cambodia is now a sanctuary of endangered wildlife. Tigers prowl imperiously down tracks where weapons-filled North Vietnamese trucks once rolled. Elephants lead their young past giant bomb craters to drink at jungle watering holes. Rare birds and apes call from treetops that used to camouflage communist soldiers from American pilots. In other areas, villagers have transformed the bomb craters into fishponds, micro-lakes filled with groundwater and rainwater that provide sustenance to the Vietnamese people.

"It will be a story of recovery," he tells me.

There is ice in the trees and the birds are puffing up to keep warm. In another life, I think my father would have been a student of birds. Sometimes I catch him watching them by his window.

I ended the year with my family in a small town outside the city. We headed for the woods. We walked in circles, making footprints in the soft snow. My elder son—big and droopy in his parka—stamped his name in a clearing. Wearing cross-country skis, my younger son plunged down a hill, then another, moving speedily through his hesitations. The woods were small and finite and it was not long before we had skied to another clearing, where we saw black crows swooping and sparring overhead. As they wheeled off into the distance we caught a glimpse of what was not finite—the sky stretching far and farther, connecting place to place, the sky across which I once, as a child, shuttled (travelling from England to Japan to Canada and back again) until I finally landed.

I have lived in Toronto almost all my life. It is a city, like most, that has only a cursory and aloof connection to nature through its parks. It is a city to which I have, until recently, had an aloof connection. I wonder if my sons will one day speak of it differently, perhaps in that truly yearnful way that is saved only for the place you came from. I wonder if birds will help them feel rooted where they land. I hope so.

For a long time I did not tell anyone I was writing a book about birds. Depending on my mood I referred to this book as "a project," "some bits of writing," and, finally, and probably most correctly: "a sketch book."

When I did finally start talking about the subject of the book, I was surprised by the number of people who shared leads or stories of their own birding passions. Everyone around me, it seemed, was a birder, salaaming the skies, organizing their lives around avian pleasures, making room for indirection, pause, whim. Nomadic in history, curiosity and creativity, they were caring of place in a way that surprised and moved me.

I wondered what united these people. Was there a common trait? Did they possess special powers of seeing, perhaps a version of the full-spectrum sight possessed by birds themselves, the ability to see in hazy conditions, to locate hidden trails? I browsed through biographies of well-known birders searching for some clue, some sense of shared outlook or purpose.

I discovered that some birders were drawn to birds for their annual migratory journeys, others for the lavishness of their appearance, others still for their inventiveness. Some started as children, others found birds late in life.

They were poets. Adults born to naturalists. Observant children. They were delinquent teenagers given a second chance, former POWs, amateur ornithologists and benign hunters. They stumbled into it. They had birds built into their DNA. They were rootless immigrants and they were rich hobbyists. They were environmental activists and

jet-set travellers. They traded the bottle for binoculars. They had lost something, hoped for transcendence, wondered how best to live this life. Birds spoke to their irrevocably blue parts, their hopeful parts. They were possessors of a peculiar loneliness. They were gregariously social. They had found the solace of life.

The birders I encountered in books and in the world shared little except this simple secret: if you listen to birds, every day will have a song in it.

Leonardo da Vinci (1452–1519) famously wrote a codex examining the flight behaviour of birds as a way of understanding mechanized flight and was a known animal rights defender. He frequented the markets of Florence, buying caged birds simply to let them go.

Charles Dickens (1812–1870) had a beloved pet raven named Grip who made frequent cameos in the writer's fiction and is said to have been the real-life inspiration for Edgar Allan Poe's "The Raven."

William Faulkner (1897–1962) was a collector of bird eggs and feeder of sparrows who always carried a piece of bread for the birds. "So does watching a bird make me feel good."

George Plimpton (1927–2003), the protean journalist, editor, and professional dilettante, embraced birdwatching as a hobby while admitting that his abilities and credentials were "slightly sketchy." "As a birder, I have often thought of myself as rather like a tone-deaf person with just a lesson or two in his background who enjoys playing the flute—it's probably mildly pleasurable, but the results are uncertain."

Rosa Luxemburg (1871–1919), known as the "revolutionary who loved birds," insisted she understood the language of birds and once proclaimed: "I am at home in the entire world, where there are clouds and birds and human tears."

Flannery O'Connor (1925–1964) raised over one hundred peacocks (in addition to hens, ducks, and geese) on her ancestral farm in Georgia. She wrote about her peacocks in "The King of the Birds," a meditation on the art of observation, told with humour, a naturalist's eye for detail, and a dash of humility—"It is hard to tell the truth about this bird."

Joseph Cornell (1903–1972) was a keen amateur naturalist and birder who often placed birds (collaged or taxidermied) in his boxes and assemblages.

Iris Murdoch (1919–1999), Booker Prize winner and bird poet (*A Year of Birds*), wrote of nature as a cure for her writerly ego: "I am looking out of my window in an anxious and resentful state of mind, oblivious of my surroundings, brooding perhaps on some damage done to my prestige. Then suddenly I observe a

hovering kestrel. In a moment everything is altered. The brooding self with its hurt vanity has disappeared. There is nothing now but kestrel. And when I return to thinking of the other matter it seems less important."

Bertolt Brecht (1898–1956) found solace in birds during his final hours at the Charité hospital in Berlin, dedicating his last poem to a blackbird he watched through his window. Reconciled with the idea of becoming "nothing," he experienced a concluding moment of peace as he imagined the song of every blackbird that would come "after" him— his heart open to the ongoing world.

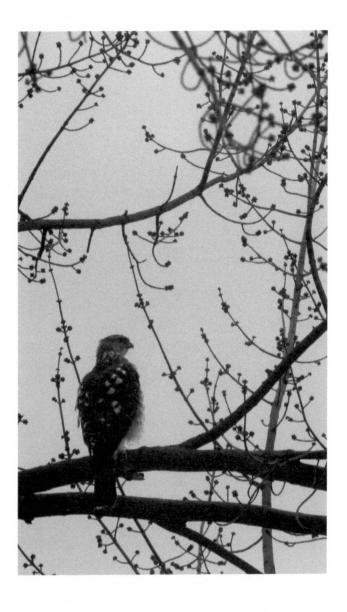

ACKNOWLEDGEMENTS

This small book owes a very big debt to the kindness and dedication of several editors: Martha Kanya-Forstner at Doubleday Canada, Kathryn Belden at Scribner, and Louise Haines at 4th Estate. Martha, your deep care and beautiful mind have made this book better is countless ways. Kathy, your editorial wisdom and great gifts of art and conversation have been a boon from the start. Louise, it has been a true honour and joy to work with you. I don't think I'll ever be able to thank any of you sufficiently for your support but I'm going to keep trying.

My heartfelt gratitude to Jackie Kaiser, agent and first reader but, most of all, a dear and steadying friend. I adore you, JK.

Your colleagues at Westwood Creative Artists continue
to sustain me in all ways. Thank you Liz Culotti, Bruce
Westwood, Jake Babad, Meg Wheeler, and particularly
Carolyn Forde for helping this book travel.

Thank you:

to all the lovely people at Doubleday Canada, including:
Amy Black, Bhavna Chauhan, Kristin Cochrane, Kiara Kent,
Melanie Tutino, Tara Walker, Ward Hawkes, Susan Burns,
Scott Sellers, Shaun Oakey, Carla Kean, Val Gow, Jennifer
Griffiths, Mary Giuliano, Robert Wheaton, Ashley Dunn,
and, last but never least, the wondrous CS Richardson
(literary compañero and art director par excellence).

to the amazing team at Scribner: Kate Lloyd, Sally Howe,
David Lamb, Daniel Cuddy, Ashley Gilliam, Julia Lee McGill,
Kara Watson, Elisa Rivlin, Nan Graham, Roz Lippel, Colin
Harrison, Susan M. S. Brown, with a deep bow to designers
Jaya Miceli and Erich Hobbing.

to the stellar crew at 4th Estate, especially: Sarah Thickett,
Michelle Kane and Tara Al Azzawi.

to Allyson Latta, Liz Johnston, Stephanie LeMenager,
Stephanie Foote, Sara Weisweaver and the editors of
Brick: A Literary Journal and *Resilience: A Journal of the
Environmental Humanities*, where elements of this book
previously appeared.

to the Toronto Arts Council, the Canada Council for the Arts, the Ontario Arts Council, and the Chalmers Arts Fellowship for financial and creative sustenance.

to Jason Logan of The Toronto Ink Company (supplier of inks), who captured my heart with his street-harvested pigments derived, as he puts it, from "sometimes overlooked urban trees, weeds, and plants from the streets, back alleys, and parks of Toronto" (i.e. the perfect drawing medium for a mongrel city-girl making a book about urban-nature). I invite you to learn more at *www.jasonslogan.com*.

to Ali Kazimi, Richard Fung, Stephen Andrews, Tarek Loubani, John Greyson, Mike Hoolboom, Brenda Joy Lem, Su Rynard, Michael Barker, Pamela Brennan and Catherine Bush for sharing art, activism, bird love, and ongoing inspiration.

to my dearest friends and family whose companionship and humour make everything possible: Nancy Friedland, Naomi Klein, Kelly O'Brien, Brett Burlock, Avi Lewis, Terence Dick, Naomi Binder Wall, Eliza Burroughs, Hiromi Goto, David Chariandy, Tara Walker; my uncles Andrew and Robin; my sons Yoshi and Mika; my parents Michael and Mariko; and my husband David, to whom this book is dedicated with Big, Big Love.

Finally, this book would not have been written without the wit and welcome of my bird guide, Jack Breakfast (a.k.a. "the musician," a.k.a. David Bell), whose bird photographs grace these pages. I encourage everyone to explore his work at *www.smallbirdsongs.com*.

I am forever grateful for your friendship and trust, JB. In your own, excellent words: "Love only! Always onward."

A NOTE ABOUT THE TYPE

Birds Art Life is set in Golden Cockerel,
originally designed in 1929 by Eric Gill for the
Golden Cockerel Press, a fine printer and publisher
founded in Berkshire, England, in 1920. The press
specialized in producing limited-edition books
featuring handmade papers, handset type, and
original wood-engraved illustrations.

KYO MACLEAR is the author of two acclaimed novels for adults and numerous beloved books for children, including *Julia, Child* and *The Good Little Book*. Kyo lives in Toronto where she shares a home with two sons, two cats and a singer.

www.kyomaclear.com